THE RAILWAY PAINTINGS OF

Malcolm Root

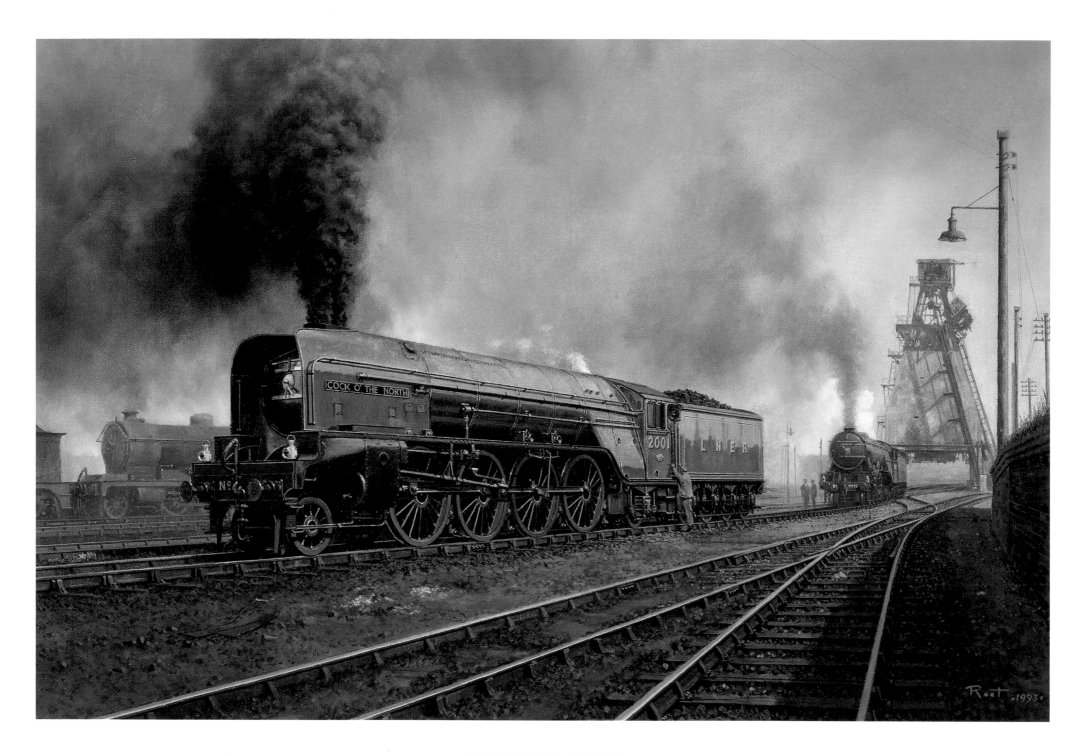

COCK O' THE NORTH

Oil on canvas, 20 × 30in (51 × 76cm), 1993
Owned by David Dickens Esq

THE RAILWAY PAINTINGS OF
Malcolm Root

MAC HAWKINS

Grange Books plc
The Grange, Units 1-6 Kingsnorth Industrial Estate
Hoo, Nr Rochester, Kent ME3 9ND
www.grangebooks.co.uk

FRONTISPIECE

Just by its sheer size and shape, this superb looking machine must have been a real treat to see; the person who commissioned the picture was of the same opinion. I have depicted the loco at York in the mid- to late-1930s as originally designed by Gresley with Lentz rotary-cam poppet valves and in the immaculate LNER apple green livery of the period. Perhaps it would have been about to work a northbound express after a visit to Doncaster Works. With the large coaling tower and other engines in view, including A3 Pacific No 4475 and a Robinson 2-8-0 goods, it is a pleasing set-up in all respects – particularly when considering York's illustrious railway history. Whether the locomotive was ever seen there in circumstances such as these, is another matter entirely; but artistic licence allows one to suggest it, which you can't do with a photograph.

The London & North Eastern Railway's Class P2 2-8-2 'Mikados', introduced in 1934, were designed specifically for use in Scotland, on the Edinburgh to Aberdeen route, eliminating the need for a second locomotive on heavy expresses. The class was rebuilt in 1944 by Edward Thompson, then the LNER's chief mechanical engineer, as A2/2 Pacifics; but the metamorphosed locomotives assumed an ungainly appearance. Although withdrawals of the class from service commenced in 1959, *Cock o' the North*, then BR No 60501 and shedded at 50A York, survived until February 1960 before being scrapped at Doncaster Works during the following April. No members of the P2 class were preserved.

This edition published in 2001 by GRANGE BOOKS, an imprint of GRANGE BOOKS plc
in association with HAWK EDITIONS
First published in the UK by David & Charles in 1996 under ISBN 0-7153-0533-6

Text copyright © Mac Hawkins 1996, 2001
Illustrations copyright © Malcolm Root 1996, 2001

A catalogue record for this book is available from the British Library.

Grange Books ISBN: 1-84013-430-5
Hawk Editions ISBN: 0-9529081-6-6

Designed and typeset by Character Graphics, Taunton, Somerset, UK
and printed in Singapore for HAWK EDITIONS, PO Box 184, Cossington, Somerset TA7 8YT, UK

CONTENTS

FOREWORD BY

His Royal Highness The Duke of Gloucester GCVO

A railway engine steaming down the track is a rare sight today but once experienced, never forgotten. Whether standing in the station, hissing with anticipation, or speeding down the line at full power, a steam engine expresses an ambiguity – is it just a mechanism, or is it animate merely needing the concern of the crew to keep it to schedule?

Malcolm Root's paintings bring back memories of when these great metal monsters were the prime movers of our extensive railway system. He has captured them with great expertise and clarity at moments when the steam and the smoke are reacting to various weather conditions, evoking the varieties of atmosphere about to be disturbed by several hundred tons of train travelling at great momentum. The noise, of course, has to be left to the imagination of the viewer but, by having a detailed knowledge of both engines and track, the painter convinces us of the exactitude and the significance of these much admired leviathans without glamourising them unduly. Smuts, dirt and even rust, have a role to play, as well as polished brass and gleaming paint work, in portraying the wide range of steam power in action.

I hope that many people will enjoy these images, reminding them of an era when hard work and long hours were expected and these splendid throbbing machines carried a large proportion of the nation from every corner, each a small part of the great organisation that was necessary to make a railway system work effectively.

HRH THE DUKE OF GLOUCESTER
Kensington Palace

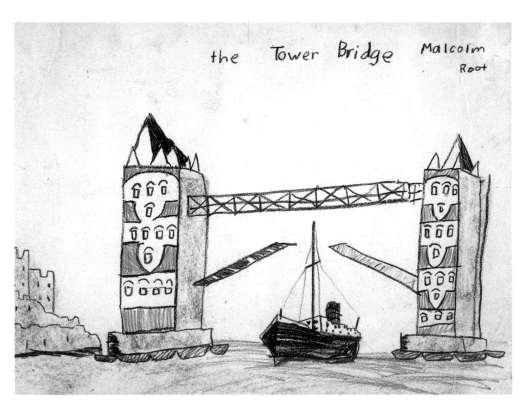

A crayon drawing of Tower Bridge by Malcolm Root aged seven, which he did from memory following a visit to London. He superimposed the ship, which is recognisable as a Cunard liner, with its distinctive red and black funnel.

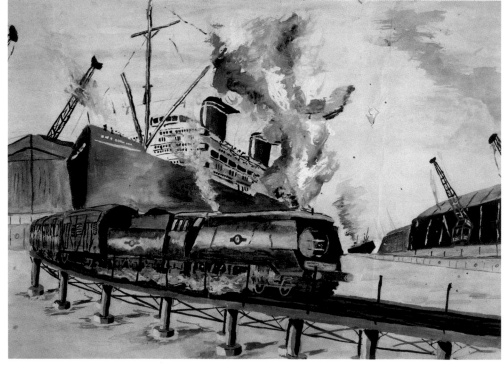

Malcolm Root's occasional visits to the docks at Southampton made an impression on him and he painted this picture when he was about thirteen. It shows a Merchant Navy class locomotive crossing a railway bridge, very like the one over the River Taw at Barnstaple in Devon – and the ship is undoubtedly the SS United States.

INTRODUCTION BY THE ARTIST

From an early age I was encouraged to draw by my parents and at infant school my teacher, Mrs Spurgeon, was also a real inspiration to me. We were taught to study things closely and to draw boldly. Fortunately my parents kept some early examples of my work, including the one of Tower Bridge (*opposite page*), which bears my name and age at that time. Like all children, other interests, such as girls and football, were natural diversions – but I still enjoyed drawing right through my secondary education. Another influence on me at school was engineering drawing, which I liked enormously and I think it has helped me with vanishing points, perspective, lines and so on.

I had hoped to get a job connected with art, but was often advised that this was a very risky profession, so I went into the printing industry with the idea of pursuing design and print typography. The design section of the firm was quite small and things did not work as planned, so my career followed a different path. However, it gave me a good grounding in the art of visual displays; and the technical side of printing is something I understand, which has come in useful when I have had prints done from my paintings.

During the time I was working in the printing industry, I continued to paint for my own enjoyment and as I still had an interest in railways, it seemed a natural progression to paint trains. This coincided with the last days of steam and when this ended, it was a way of recreating scenes I remembered. In those early days, my pictures were mostly water colour or pencil drawings; but when in my twenties, I started using oils and felt comfortable with the medium straight away. Having done a couple of train pictures, some people that saw them indicated they would be interested in buying one or two. Eventually it got to a stage where I had quite a lot of commissions, but was still working in the printing industry. During this time, I often wondered whether I should consider taking up a painting career. The chance of voluntary redundancy came in 1981 and I finally took the plunge and became a full-time artist.

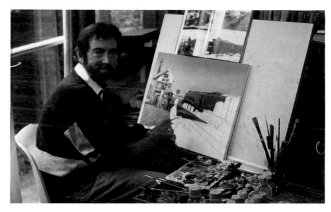

The artist in his Essex studio. On the easel is Streaking Past, *one of the paintings featured in this book.*

Photograph: Nick Pigott.

All the way through life – right from my early days – I was encouraged to study things closely and to observe. I do think that 95 per cent of an artist's work really comes from observation: walking along the road, or peering out of a window at home, you can see how sunlight falls on cars and buildings, and casts shadows. Looking at skies you can note how light plays on trees and how cloud shadows move across the ground and so forth. The most difficult part of painting is remembering what you have seen and transferring it onto canvas. I do not think it is true to say all the skill is in the hands: if you lost the use of the one you normally paint with, you could still use the other – after a fashion! We often hear of talented people who paint by mouth or foot, so much of the skill is lodged somewhere in the brain and only partly in the limb.

I am fortunate in that my memory is reasonably good – particularly of my childhood – and this has helped me include in pictures little details I might have otherwise forgotten. For instance, I can remember on a rainy day when a train came to a stop in a station the water would run forwards along a rain strip and off the front of the coach, like a mini-waterfall. I also recall where mud stains and general weathering around the beading of coaches remained – even if they had just been cleaned. One tends to recall things which left an indelible mark on you and the

beauty of a painting is that you can include many of them in your work. This is especially important when doing a historical painting, because it can bring it to life, and little period details can help date a picture accurately.

Regarding style, mine has not changed that much, although everybody who paints would say theirs does alter over the years – but one should still be able to tell who painted it, besides noticing the signature! In my early days of oil painting, my style tended to be quite coarse and more impressionistic. I do owe something to the Guild of Railway Artists insofar as when I first submitted my train paintings, the general criticism was that the locomotive was fine, but the background was not of the same quality nor style. One needs this kind of constructive criticism, because you can be almost blind to your weak points. I certainly took this on board and I am very grateful to the GRA. I think it is so important to try and do better with every picture and always strive to achieve new goals – otherwise one should give up! I feel my pictures are more detailed now than in the early days. However, there is a fine balance between getting the accuracy right and retaining the feeling that it is still a painting. One ambition was fulfilled in the late 1980s, when I was commissioned by British Telecom to do a series of five paintings of museums for the covers of their phone books. It was a departure from railways, which I found challenging and rewarding artistically.

Life as an artist has not always been easy; nevertheless it has been a very satisfying career, but without the support of my family and friends over the years, it would have been impossible to pursue. From the earliest days, when I started to paint seriously, I harboured the ambition to have a collection of my paintings published at some time in the future: it would be the icing on the cake and now this has been achieved, I hope many others will also be able to enjoy it!

MALCOLM ROOT
Halstead, 1996

COASTING DOWN TO KYLE

One of the part owners of the preserved 'Black Five' locomotive depicted here wanted it portrayed in a particularly fine setting; this composition is the result. It is an area I know fairly well, having spent two holidays at Plockton in north-west Scotland – not a very romantic sounding place, but nevertheless a spectacular one. It's just a fabulous spot combined with a most scenic line and the picture shows the train in that sort of landscape during late summer going towards the Kyle, a few miles away.

The bridge is over a little stream coming down from the mountains into an inlet of Loch Carron. Getting the perspective right was no problem, as I took some photographs of the landscape when on holiday there, but one of the nice things you can do with paint is to alter viewpoints!

The terminus at Kyle of Lochalsh, the ferry port for the crossing to Skye, opened on 2 November 1897. The line was built in two stages by the Dingwall & Skye Railway (later part of the Highland Railway, an amalgam of several small companies) and the first terminus, at Stromeferry on the banks of Loch Carron, opened on 19 August 1890.

The line from Dingwall presented quite an engineering challenge and was the most expensive constructed to that date, costing a phenomenal £20,000 per mile. This was due to the 31 rock cuttings that had to be blasted and 29 bridges which had to be built. The last 10½ miles (17km) took four years to construct: nearly as long as the section from Dingwall to Stromeferry. The gradients were also severe: shortly after leaving Dingwall,

trains were faced with a gruelling 4-mile (6km) climb at 1:50 from Fodderty Junction to Raven's Rock Summit, broken by a short stretch of 1:350 through Achterneed station. Switchbacking for most of its length, the line's summit at 646ft (197m) above sea level was reached at Luib, just over thirty miles (48km) from Dingwall. The line still serves this remote area and is also a much under-appreciated tourist attraction, which is seldom reached by special trains, whether steam or diesel.

The Cumming and Jones Goods 4-6-0s were the mainstays of the line until the mid- to late-1930s, when the Stanier 'Black Fives' appeared on the scene. In its latter BR years, Class 5 4-6-0 No 45163 was based at Carlisle Kingmoor shed, before its withdrawal in May 1965.

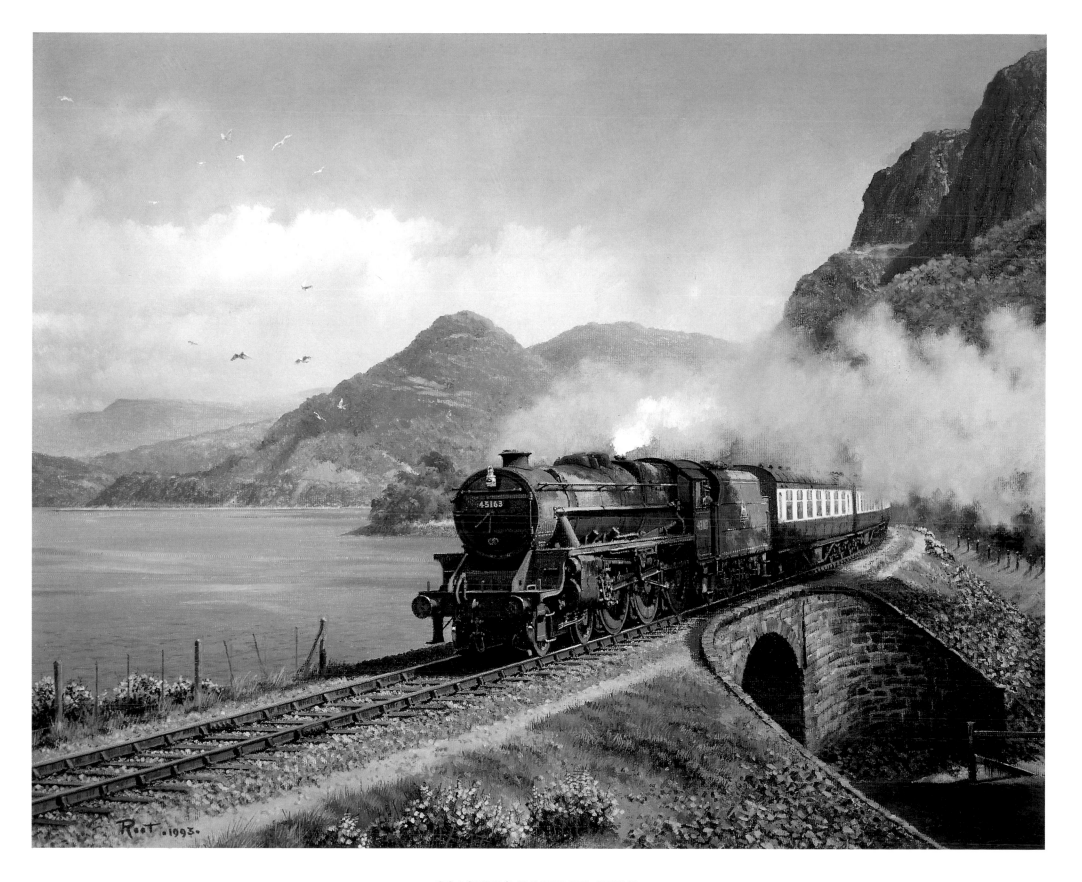

COASTING DOWN TO KYLE
Oil on canvas, 18 × 22in (46 × 56cm), 1993
Owned by Jeremy Dunn Esq

SKIRTING THE SEA WALL

The classic setting of a train passing along the sea wall near Holcombe in south Devon, with the red cliffs and Teignmouth church in the background, is familiar and most attractive. No matter how often this spot has been photographed or painted, it still conjures up that certain magic for me, which goes back to boyhood dreams of those halcyon holidays spent at the seaside where you could watch trains as well as playing on the beach – although when the tide was in here, you couldn't! One of the boys has the familiar duffle bag of the period, and a loco-spotter's notebook to hand in case he spies a 'cop', and they are getting as close as possible to the line to watch the passing train.

With careful use of light and shade, I have tried to create the impression of a hot summer's day – it's what everybody imagines the weather to have been in their youth and nobody remembers the really cold days. In fact quite a chilly breeze would have to be blowing to create the steam effect shown here. Sometimes you have to cheat a bit to give the picture life. One unavoidable problem was the continuous line of the sea wall and the signal, which could have distracted the eye, and that is why the figures were put in to help break it up.

CASTLE CONTROL CENTRE

Although wonderfully scenic, the Great Western Railway's route along the coast between Dawlish and Teignmouth has presented problems over the years when severe winter gales have lashed the retaining wall, occasionally breaching it, thereby closing the line. Trains could be redirected onto the Southern Railway's route between Exeter and Plymouth, but with its severance between Bere Alston and Okehampton in May 1968, this is no longer an option.

Of a Collett design first introduced in 1923, the GWR Castle class 4-6-0s were phenomenally successful express locomotives; in fact the last batch was built at Swindon Works under the auspices of British Railways after the first of the class had been withdrawn. No 5007 *Rougemont Castle* was latterly fitted with a Hawksworth flat-sided tender, as shown in the painting. It spent its last days working out of 85B Gloucester Horton Road depot, being withdrawn from service in August 1962 and scrapped at the end of the year.

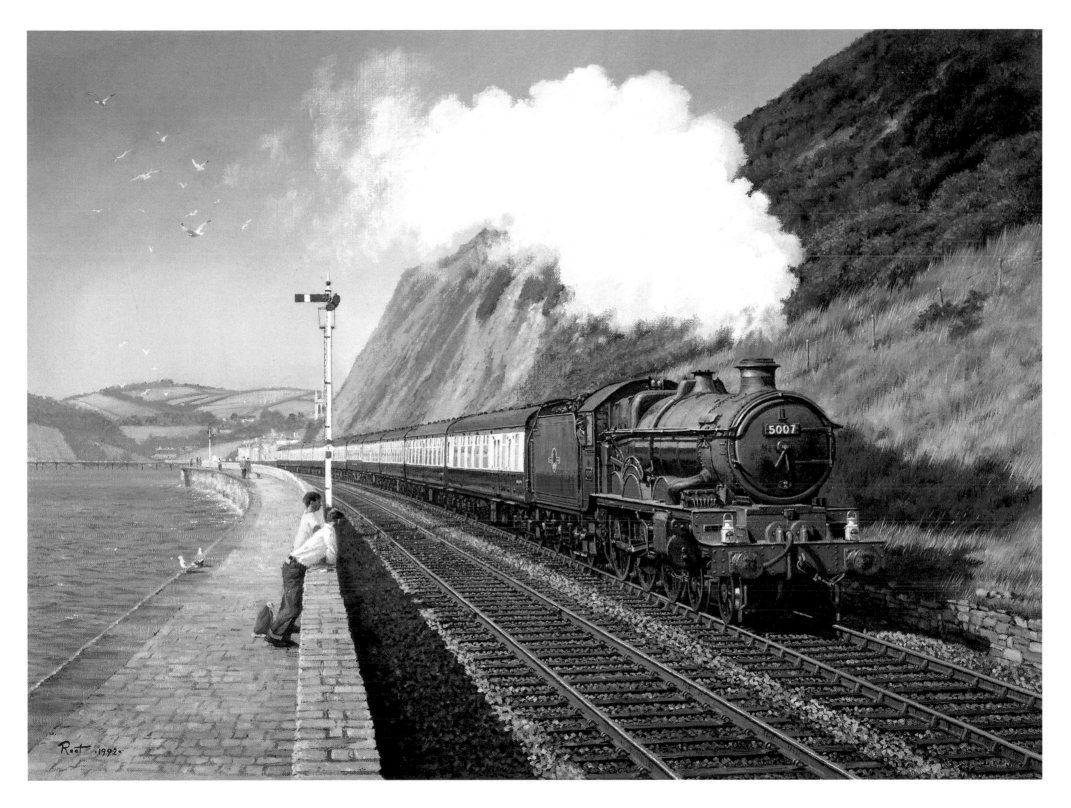

SKIRTING THE SEA WALL

Oil on canvas, 18 × 24in (46 × 61cm), 1992
Owned by Burnley Moses Esq

11

POLISHED PERFORMANCE – Shining the Football

Robert Clow commissioned this painting because he has the nameplate of this locomotive. The B17 is a particular favourite of mine – I remember seeing them on the Great Eastern section of British Railways in the late 1950s – and I love football, so the two naturally went together.

A lot of people said the B17s were rough-riding machines but I have it on good authority that, when new and well cared for, they were very smooth for footplate crews.

This picture was achieved with the help of the owner placing a ladder against his garden shed, which had a strong roof and happened to be 6ft 8in (2.03m) tall – the height of the locomotive's wheels – so the nameplate was positioned on top and he climbed up to adopt a suitable pose whilst I sketched him supposedly cleaning it. The fact that he was wearing railway gear at the time certainly amused some of the neighbours!

I think the result might give an idea of the everyday life of the railway workman. In scenes like these, it is important to include the paraphernalia normally associated with such tasks, like the cotton waste which used to be soaked with an oil and paraffin mix and used for cleaning the locos. Although this is essentially an imaginary BR scene, the 'LNER' lettering on the ladder is a reference to earlier days of the railway, where often old equipment that was inherited on nationalisation was used for years and years after. I also have endeavoured to show, although they were originally painted black, that the wheels have turned a browny colour due to them constantly being cleaned with oil then covered in grime.

STEAM – THE LESS GLAMOROUS SIDE

Designed to give more power while still meeting the engineering restrictions of the ex-Great Eastern lines, the B17 4-6-0s were introduced in 1928 and underwent various boiler and tender changes over the years. Until the arrival of the BR Britannia class Pacifics in the early 1950s, the 'Sandringhams' were the mainstay of passenger services to and from London Liverpool Street, along with the Thompson B1 4-6-0s.

No 61664 *Liverpool* spent most of its last years in service based at 32D Yarmouth South Town depot before withdrawal in June 1960. It was cut up for scrap at Stratford Works the same month and was one of the last of the class to remain in use. By the late summer of 1960, all had suffered the same fate and none was preserved.

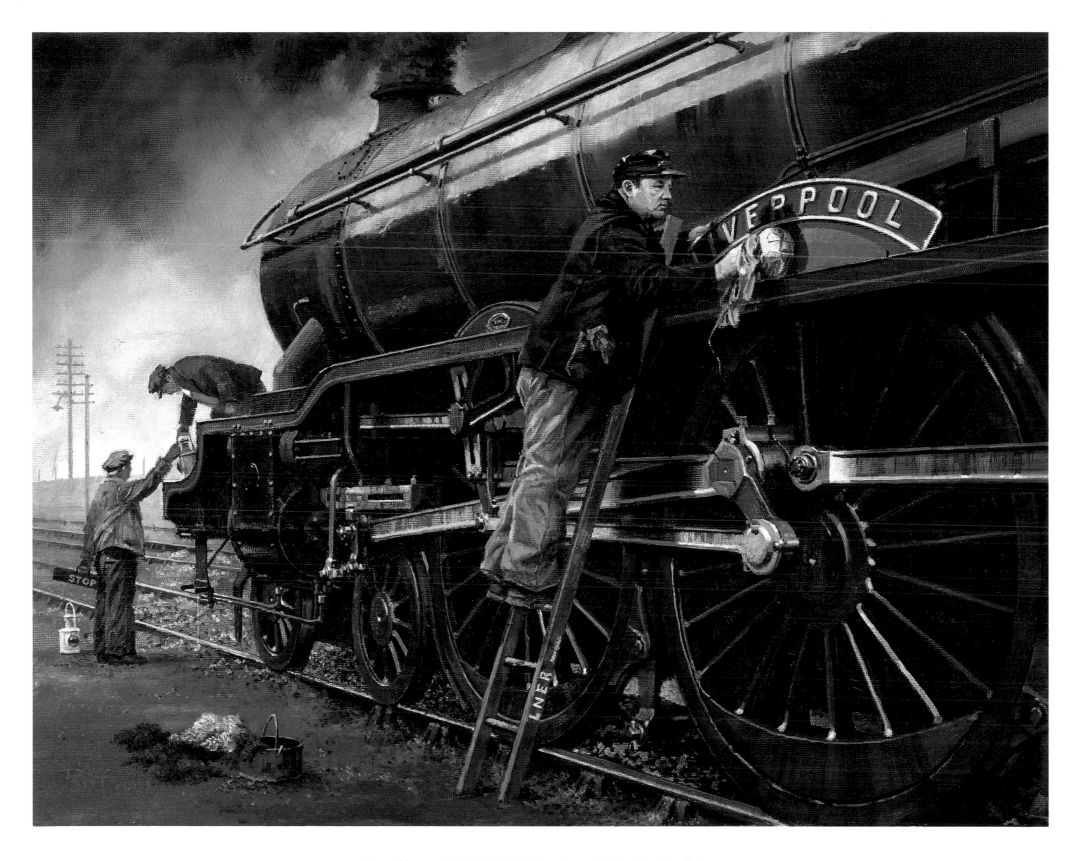

POLISHED PERFORMANCE – Shining the Football

Oil on canvas, 14 × 18in (36 × 46cm), 1993
Owned by Robert Clow Esq

QUICKSILVER AND THE 'SILVER JUBILEE'

This picture of *Quicksilver* with the 'Silver Jubilee', emerging from the north end of Copenhagen Tunnel and up Holloway Bank out of London Kings Cross, was commissioned by a gentleman who was on the footplate of the locomotive in BR days. He was building a 5in-gauge model of it and wanted a picture of it in its original condition when it was used to haul the express in the mid-1930s. The streamlined A4 class locomotive is shown in a fairly clean state,

with not too many dirty streaks in evidence on the boiler casing. In those early days the nameplates were painted on the sides, but later they were cast in brass.

The chap in the allotment with a bottle of beer in his hand was partly inspired from my memories as a lad of seeing people working on their vegetable plots, particularly on a Sunday morning. Two things that stick out in my mind are the smell of bonfires and people with rolled up shirt

sleeves – often they kept a bottle of beer or two in the garden shed for refreshment! The smoke from the loco's exhaust is probably a little over the top, but sometimes it gives a bit more power to the picture and of course it looks good when it hangs under bridges and tunnels. However, it is also important to show familiar landmarks so there is no doubt as to the location. The signals had to be accurate and I discovered that this section had been re-signalled before the introduction of the 'Silver Jubilee'. The trackwork was no problem as plenty of photographs are available of this spot, but what was a little tricky was to get the livery of the coaching stock right, as this was one of the cases where very few colour photographs exist. The loco's buffers have been 'quartered' – a practice which used to go on then, as it did occasionally in BR days. This was achieved by applying horizontal and vertical strokes on alternate 90-degree segments, using emery paper.

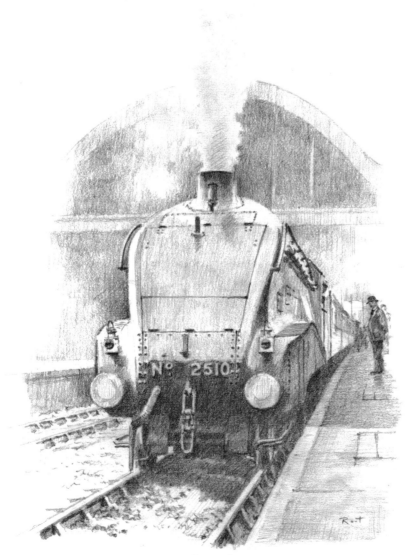

SILVER STREAK

The brainchild of Sir Nigel Gresley, who sought authority to build a streamlined train for the East Coast main line, the 'Silver Jubilee' was introduced on 30 September 1935 to provide an unrivalled service between Newcastle and Kings Cross. The journey of 268.3 miles (431.9km) took four hours with only one intermediate stop at Darlington – an average speed of 67.1mph (108kph). It left Newcastle at 10.00 for London and returned to Tyneside departing Kings Cross at 17.30 the same day. Four new streamlined locomotives, designated A4 class Pacifics, and a luxury seven-coach train were built for this service.

The inaugural trip was made with the first A4 to be completed, No 2509 *Silver Link*, which, during a test run a few days after it entered service, raised the world speed record to 112.5mph (181.1kph), covering a distance of 43 miles (69km) at an average speed of 100mph (161kph). The other locomotives in the initial batch of A4s were No 2511 *Silver King*, No 2512 *Silver Fox* and of course No 2510 *Quicksilver*. Today the fastest scheduled train journey between Newcastle and Kings Cross takes a little under 2¾ hours.

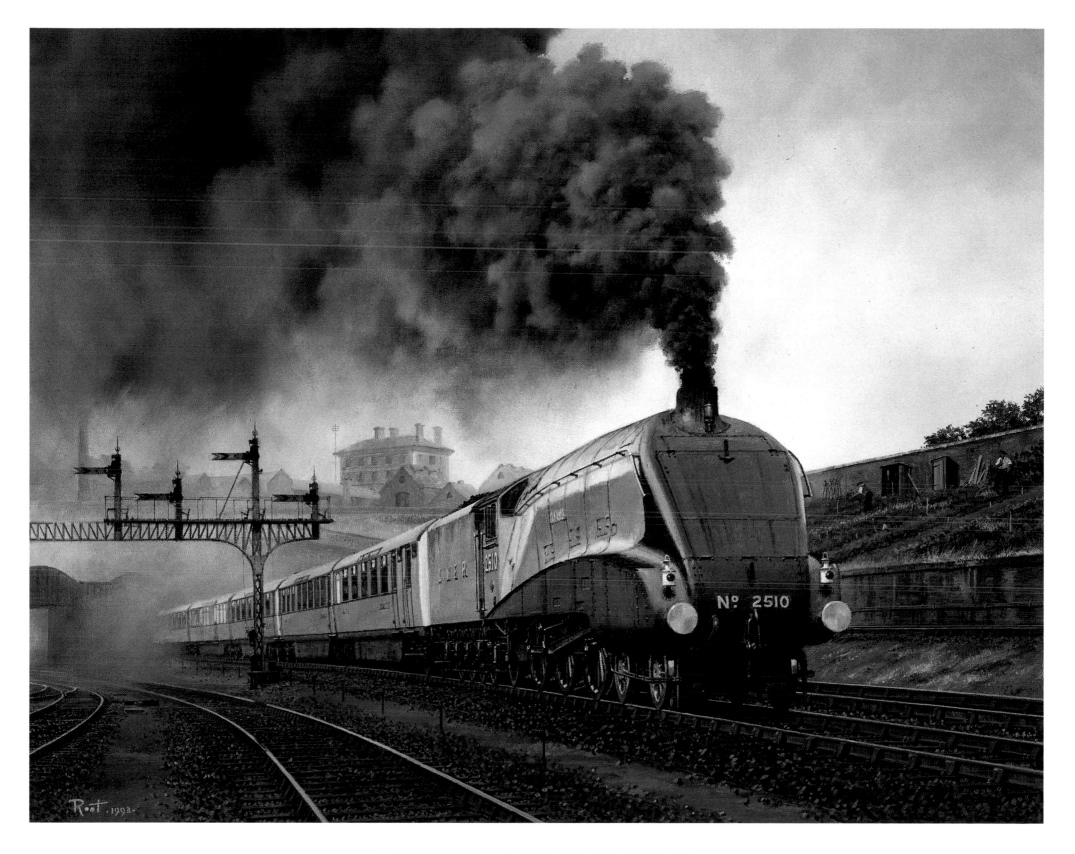

QUICKSILVER AND THE 'SILVER JUBILEE'
Oil on canvas, 20 × 24in (51 × 61cm), 1993
Private collection

PRESTIGE AND POWER – the 'Golden Arrow'

In the early 1950s a Merchant Navy class Pacific was a familiar sight at the head of the 'Golden Arrow' boat train as it left London's Victoria station for the Channel coast. The exit from Victoria offers plenty of scope to the artist: one can show an engine working hard on the 1:62 rising gradient as it rounds the curve and heads towards Grosvenor Bridge over the River Thames shortly after leaving the station. In contrast to much brighter scenes, it is gratifying to be able to depict a typically damp and misty day – a totally different atmosphere, which presents other challenges for me. The dampness of this dismal day is perhaps illustrated by the train's reflection on the sleepers; also the locomotive has its steam sanders on to maintain grip on the slippery rails as it struggles with its heavy load. The landmark of the BOAC airline building is just visible in the background through the murk.

I am very fond of blue for locomotives – I think it's a wonderful colour. The books I had when young invariably showed large passenger engines in blue livery, which is probably why I like it so much. British Railway adopted blue in the early 1950s for Class 8 passenger locos and it suited the 'Merchant Navies' very well, but, in my opinion, not the ex-GWR 'Kings'. In reality the colour didn't wear well and used to fade, so they stopped using it and adopted brunswick green.

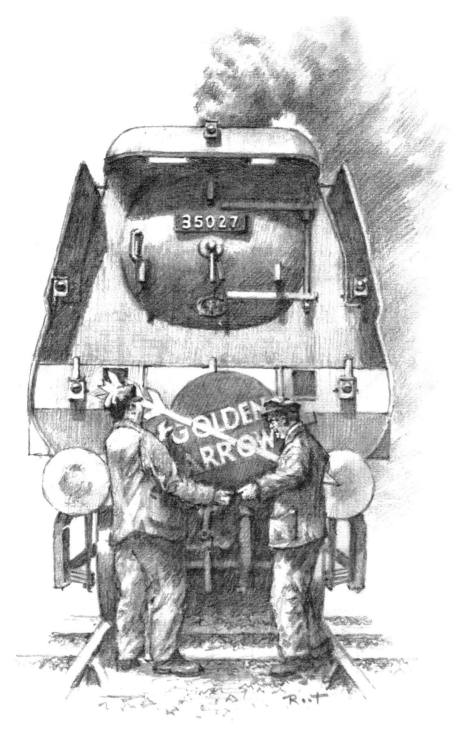

NAMING THE TRAIN.

The doyen of Southern luxury travel: inaugurated on 15 May 1929, the 'Golden Arrow' provided a first-class Pullman service from London Victoria to Dover (later Folkestone) to connect, via cross-Channel ferry, with the Calais–Paris *La Flèche d'Or*. Due to the trade depression, from the summer of 1932 the train ceased to be an exclusive Pullman service and was not reinstated as such until 15 April 1946. Apart from the war years, the 'Golden Arrow' survived in various forms until 30 September 1972; however, the last steam-hauled train was on 11 June 1961.

Constructed at Eastleigh Works in 1948 with air-smoothed casing, as represented in this painting, Merchant Navy class Pacific No 35027 *Port Line* was rebuilt in 1957. It was eventually withdrawn from service in September 1966 and following years in a scrapyard at Barry Docks, where it went in March 1967, was eventually saved from the cutters' torch and now resides on the Bluebell Railway in Sussex.

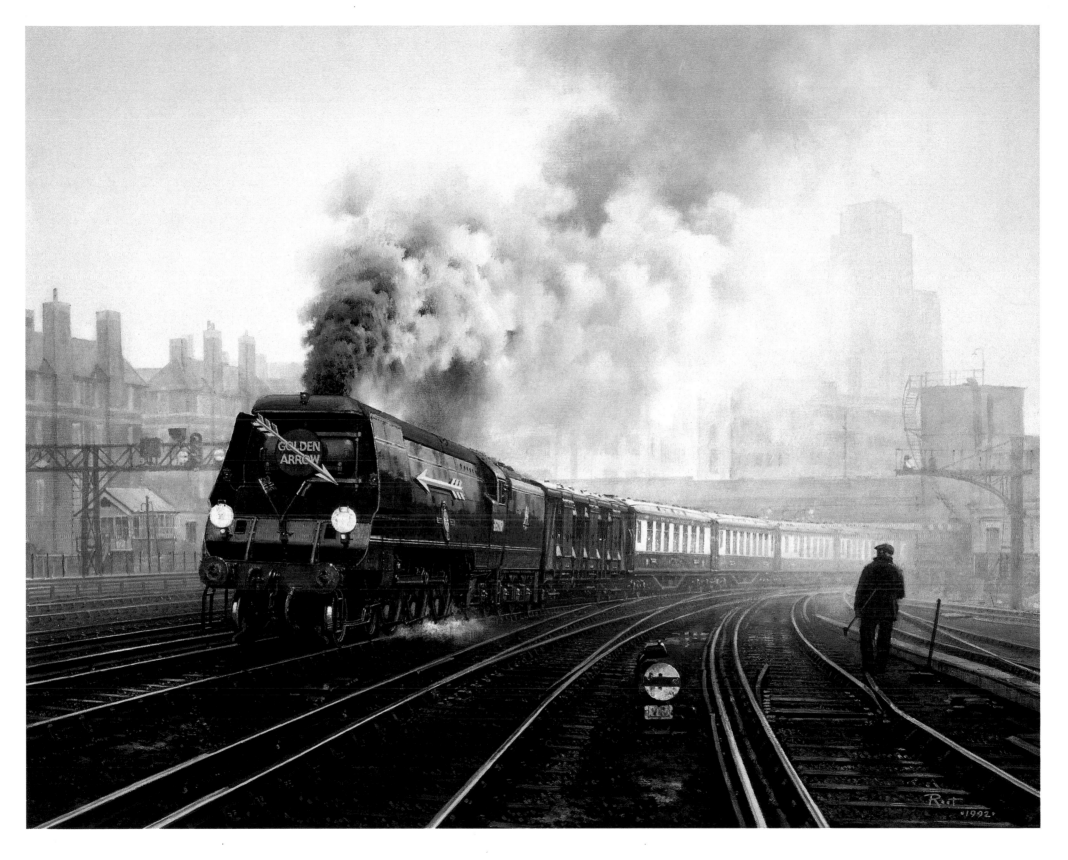

PRESTIGE AND POWER – the 'Golden Arrow'

Oil on canvas, 24 × 30in (61 × 76cm), 1992
Owned by Burnley Moses Esq

COALING A PACIFIC

This picture of London Kings Cross coaling plant was commissioned by someone living locally. It was a scene he remembers and has taken many photographs of, but I was able to position the locomotive more favourably underneath the coal tower and generally move things about a bit to make the painting work. Although engine shed scenes tend to be very drab and dismal, it is surprising what colours you can get from a subject like that. Skies which are visible only in the distance tend to appear a bit lighter, so it is always nice to use a fairly pure colour for this and cobalt violet is a particular favourite of mine for this application.

One of the handsome Gresley-designed A3 class Pacifics of the London & North Eastern Railway, No 60066 *Merry Hampton* named after a racehorse, fitted with a Kylchap double chimney and German-type smoke deflectors, stands under the coaling plant at London Kings Cross to have its tender replenished prior to working an express on the East Coast main line. The painting depicts a scene from the early 1960s when the Pacific was getting towards the end of its life. In the background are other engines standing outside 'Top Shed' at Kings Cross: the ex-LNER motive power depot was one of the busiest and best known in the capital.

Built at Doncaster Works, the A3 class was first introduced in 1927 and its most famous member hardly needs an introduction: No 60103, *Flying Scotsman*, was the first locomotive officially credited with exceeding 100mph (161kph). No 60066 spent most of its latter years based at Kings Cross, whose shed code was 34A. *Merry Hampton* was withdrawn from service in September 1963 and scrapped at Doncaster Works the following month.

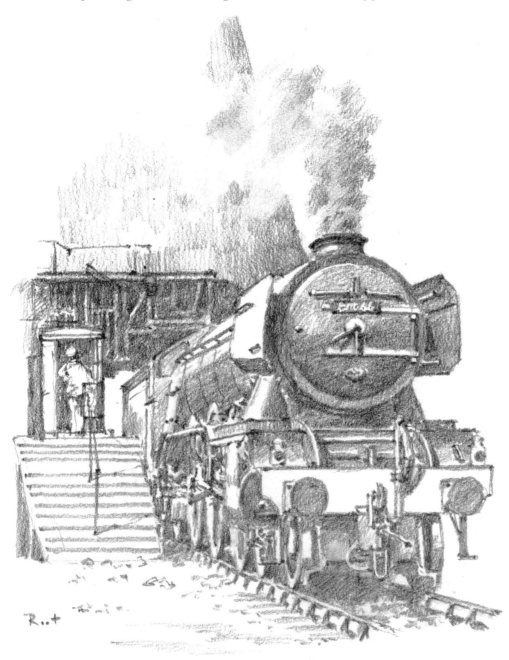

FUEL FOR A FLYER.

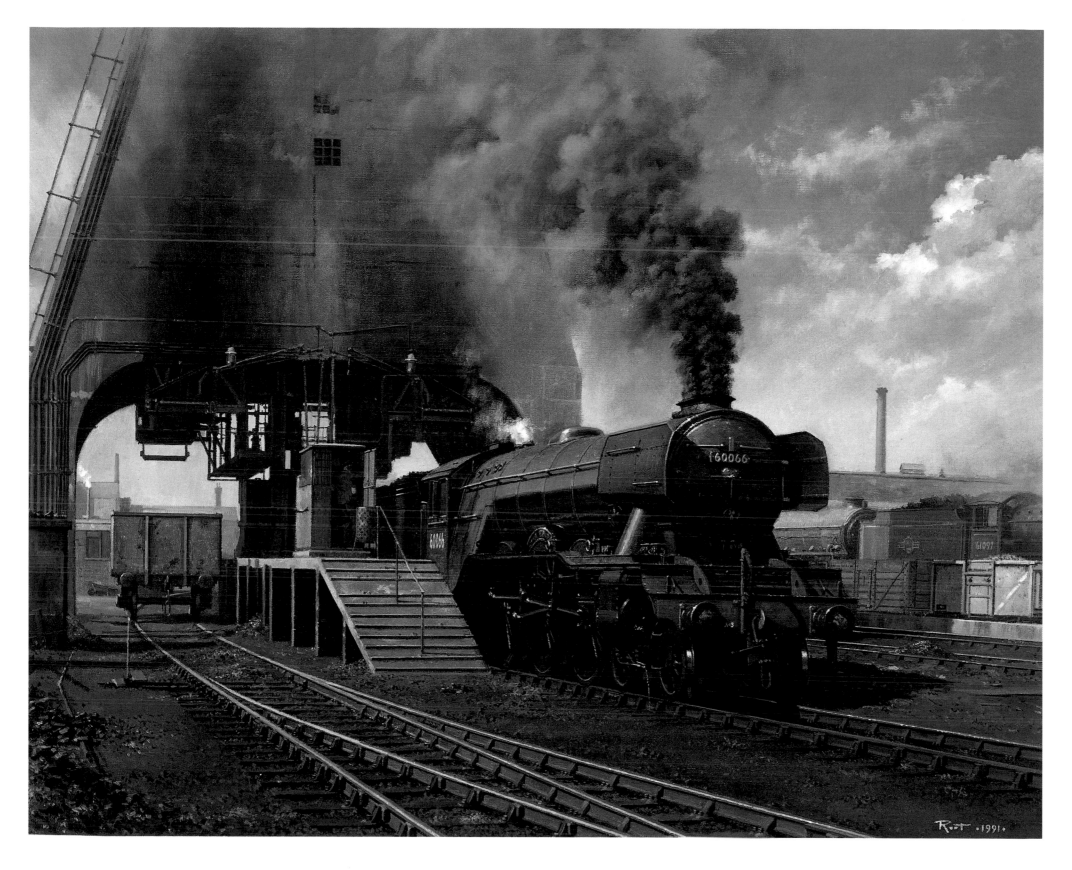

COALING A PACIFIC

Oil on canvas, 24 × 30in (61 × 76cm), 1991
Private collection

19

SHANE'S CASTLE

I thoroughly enjoyed painting this picture of the little Shane's Castle Railway in Co Antrim, Northern Ireland, commissioned by Lord O'Neill. It had been planned that I should go across to Ireland for the Ulster Traction Engine Rally, held on his estate over two days in July 1990. This trip was to make sketches and take photographs of the Shane's Castle Railway itself, of which Lord O'Neill was extremely fond. However, he requested that his Burrell scenic showman's road locomotive, *Quo Vadis*, the Scammell Showtrac lorry and Marenghi fair organ should also feature in the painting.

My main problem was to get everything together in a pleasing composition. This proved a little difficult, because not only did the location have to be unmistakable, with part of the main castle visible, but also the railway station there had to be shown to its best advantage, as well as the showman's engine and other machines. The best solution we could come up with was to depict the Burrell alongside the railway, although it wasn't actually in that position and had to be superimposed! Also, if I remember rightly, engine No 1 was in the works at the time, but as Lord O'Neill wished it to feature in the picture, a bit of artistic licence was permissible. What particularly impressed me about this location were the magnificent trees. I do like painting trees. It's quite a pleasing escape from the exacting task of painting railway locomotives and tracks – people don't usually count the leaves on trees! It was a superb visit and I thoroughly enjoyed the company and the warmth of the people there.

The first railway at Shane's Castle dated back to the post-war years when a 2ft-gauge (60cm) military railway existed here. Although the Railway Preservation Society of Ireland, formed in 1964, had devoted itself to the standard gauge (5ft 3in or 1.6m), no organisation existed to preserve the numerous 3ft-gauge (91cm) railways that were once such an important part of Irish transport.

From 1966, when he first began to give serious consideration to the project, Lord O'Neill gradually built up a collection of railway equipment, including three steam and three diesel locomotives. The culmination of his efforts resulted in Shane's Castle Railway being opened in May 1971.

The locomotives featured in the painting are 0-4-0T No 1 *Tyrone* (built in 1904 by Peckett & Sons of Bristol), which for many years worked at the port of Larne for the British Aluminium Company, and 0-4-0WT No 3 *Shane* (Andrew Barclay No 2265), which had been bought by the Irish Turf Company, Bord na Mona, in 1949 and worked for three years on Clonsast Bog to convey turf for fuelling the Portarlington power station.

The Burrell special scenic double-crank compound engine was built in 1922 (maker's number 3938) and was one of 16 such machines made by the company, of which only nine survive; it was purchased in April 1989. During the same year Lord O'Neill purchased the Scammell Showtrac, named *The Showman*, which was originally supplied to Anderton & Rowland in 1948. Thought to date from around 1910, the showman's fair organ was built by C.H. Marenghi & Cie, Paris. It spent several decades working in Germany and Holland before being acquired by Lord O'Neill, also in 1989. Sadly, Shane's Castle Railway closed in September 1994.

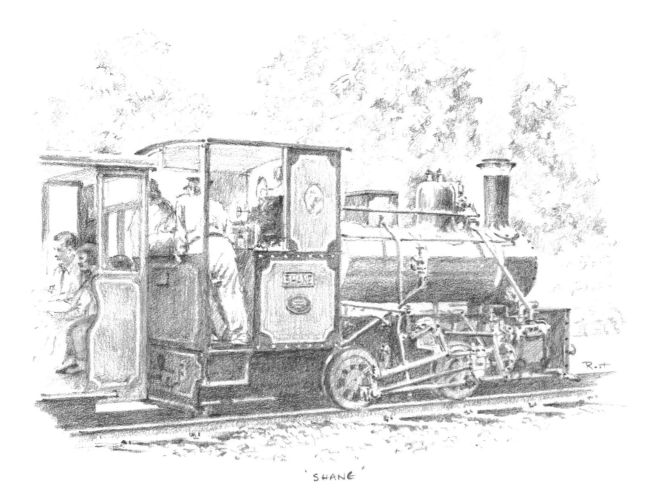

'SHANE'

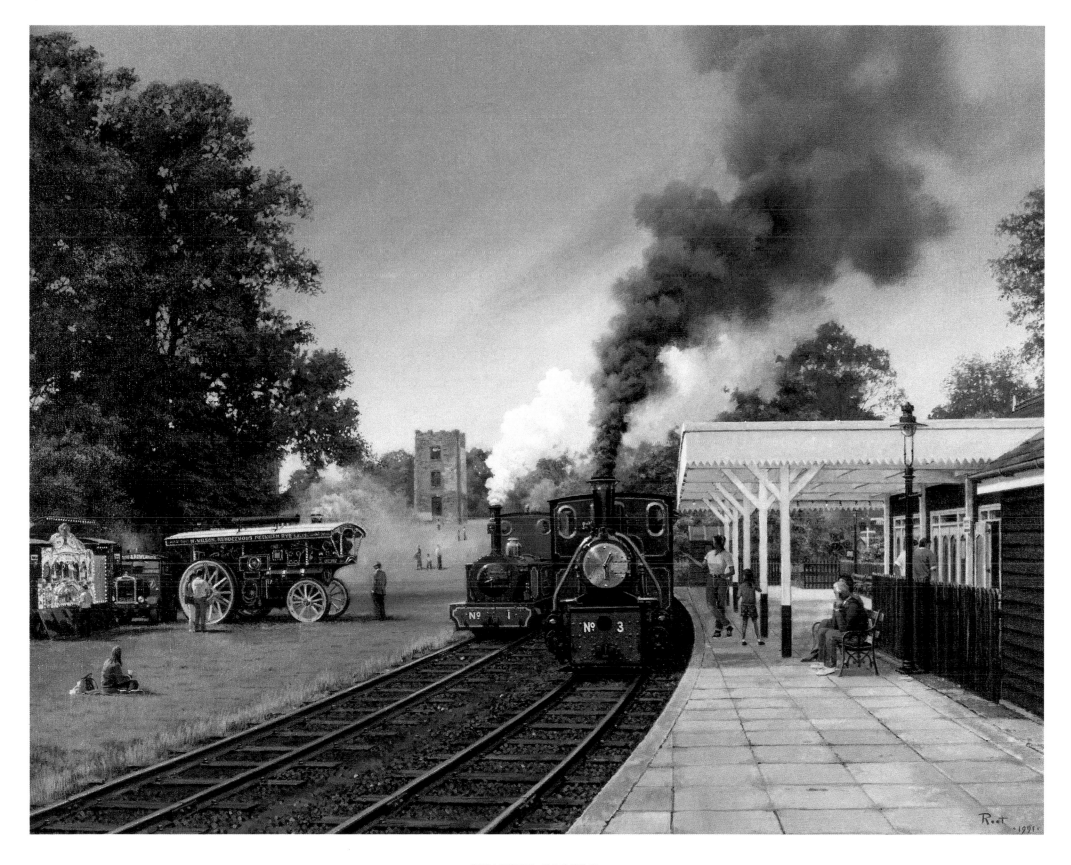

SHANE'S CASTLE
Oil on canvas, 24 × 30in (61 × 76cm), 1991
Owned by The Lord O'Neill

TURKISH DELIGHTS

I had a phone call out of the blue one day. The voice on the other end said: 'This is Detective Superintendent Kemp of the Police Fraud Squad'. I didn't know quite what to say and for a fleeting moment quaked in my shoes wondering what on earth I had done wrong! He then went on to say that over the years he had travelled extensively by rail in foreign countries and, as he was shortly leaving the service, would like a picture done for his retirement. I breathed a huge sigh of relief. He went on to explain that some of his most memorable trips had been to Turkey and therefore would like a picture showing a typical steam scene on their state railways.

The picture was painted from the photographs he supplied, which showed trains leaving the town of Izmir on the Ægean. They appear to be working very hard on a stiff curving climb, as illustrated by the amount of black smoke; the train comprised four coaches and about two dozen wagons.

The composition presented me with a variety of problems, as one can judge by the number of buildings seen here. It wasn't going to be that easy to paint these accurately and I omitted some of the minute detail. However, what I most importantly wanted to do was give an impression of looking down on the train, but with the hous-ing rising on the hillside in the background. The impressive ruin of the Roman aqueduct is an interesting feature and the lady goatherd tending her charges in the foreground helps add some scale to the picture.

My technique in painting such a picture as this, which has so much detail, is to start the background first and then work gradually forward to paint the main subject and foreground much more strongly, giving a feeling of depth. If you are not careful, you can make the background stand out far too much and lose the desired effect. A complicated painting like this takes me three or four weeks to complete.

HENSCHEL AND KRUPP 2-10-2

The leading locomotive in the picture is a Prussian G8 0-8-0 (Turkish Class 44XXX) and the second engine a Class 57XXX 2-10-2, which are featured working the 'Denizli mixed', leaving Izmir Alsancak at 09.35. Although regular steam workings had largely finished on the TCDD (Türkiye Cumhuriyeti Devlet Demiryollari) during the late 1980s, some of the remaining engines were used frequently on charter and tourist trains, including the 2-10-2s.

A large fleet of steam locomotives still survives in Turkey at various dumps around the country and many could be made serviceable without too much of a problem – and as demand dictates. These engines have wide-ranging pedigrees but are generally Czech, German or British origin, including Class 8F 2-8-0s, of which 18 survive (there is also a sole example in Iran). One has been re-imported to Britain and is on the East Lancashire Railway, Bury, carrying number 45160. Originally it was a War Department-operated machine, built in 1941.

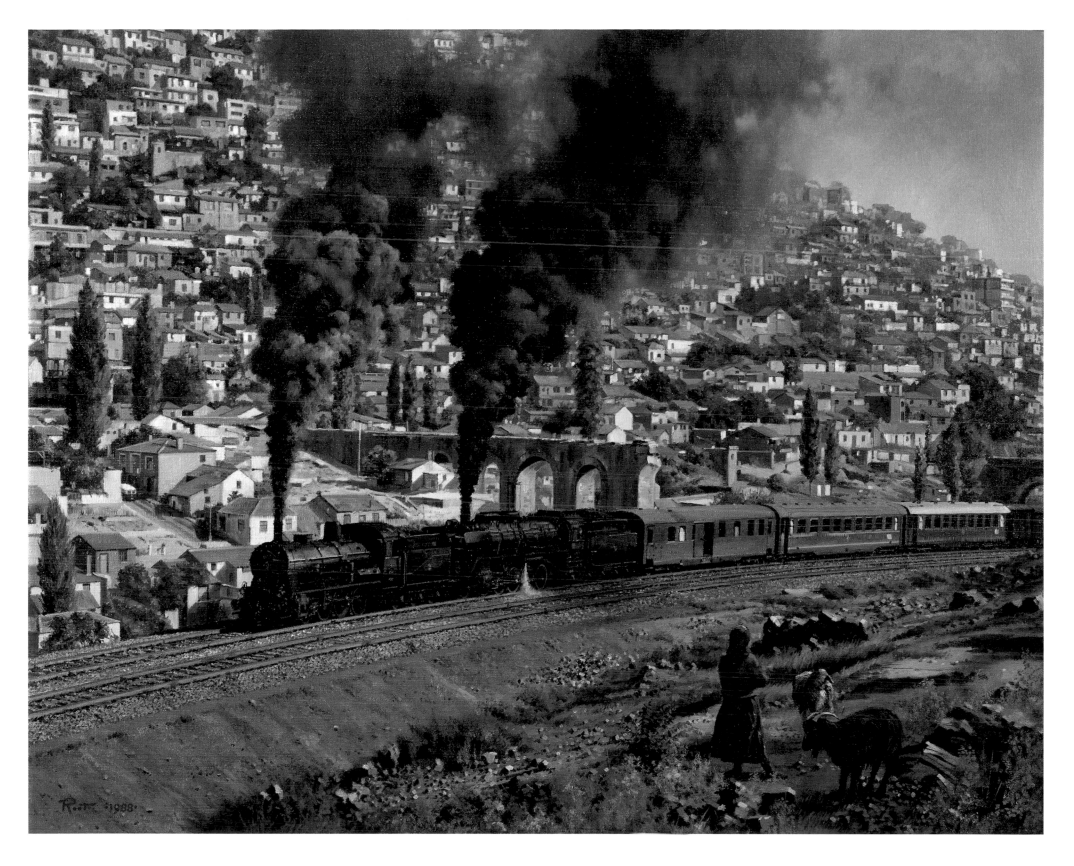

TURKISH DELIGHTS

Oil on canvas, 24 × 30in (61 × 76cm), 1988
Owned by John Kemp Esq

WEYMOUTH TURNAROUND

In some respects, railway life was quite hard and this is illustrated here with the crew of a Merchant Navy Pacific struggling to turn the heavy locomotive on the manually-operated turntable at Weymouth, which must have taken every ounce of strength. One of the crew appears to be working very hard whilst the other, nonchalantly clenching a pipe in his teeth, seems to be showing little effort – perhaps due to a bad back! The turntable is in a pretty dilapidated and rusty state with weeds growing all around – typical of the late steam era, which this picture represents.

One can get some quite dramatic colours in the trackwork, where ash and other detritus have been dropped onto it: a surprising variety of tones can be employed to good effect in recreating the scene accurately. A strong breeze is indicated by the locomotive's smoke blowing sideways and towards the sheds in the background; its blackness suggests the fireman has just made up the fire in preparation for the return journey. Alongside the turntable is a typical cast iron railway notice. Such artefacts have great appeal to the collector these days and as a result such items are becoming increasingly more expensive.

The 65ft (19.8m) turntable at Weymouth was a Great Western Railway structure dating from 1925 and replaced an earlier one, which could swing only a 50ft engine. Some turntables were powered using a locomotive's own vacuum system and others could be cranked by hand through a reduction gearbox, thus saving considerable muscle power and effort for footplate crews. At over 150 tons laden, including tender, the Merchant Navy class were the heaviest engines to be turned regularly at Weymouth. The positioning of a large locomotive on a turntable was crucial in order to get the balance right, especially if it was to be swung manually.

Rebuilt in March 1957, Merchant Navy Pacific No 35017 *Belgian Marine* was based at 70A Nine Elms depot until September 1964, when it was transferred to 70G Weymouth shed, from where it was withdrawn in July 1966 and subsequently scrapped. Steam on the Waterloo–Weymouth route was to last a further year or so; however, the final steam working from the town, a Weymouth–Westbury fruit train, was on 7 July 1967; the shed closed two days later.

FLYING THE FLAG

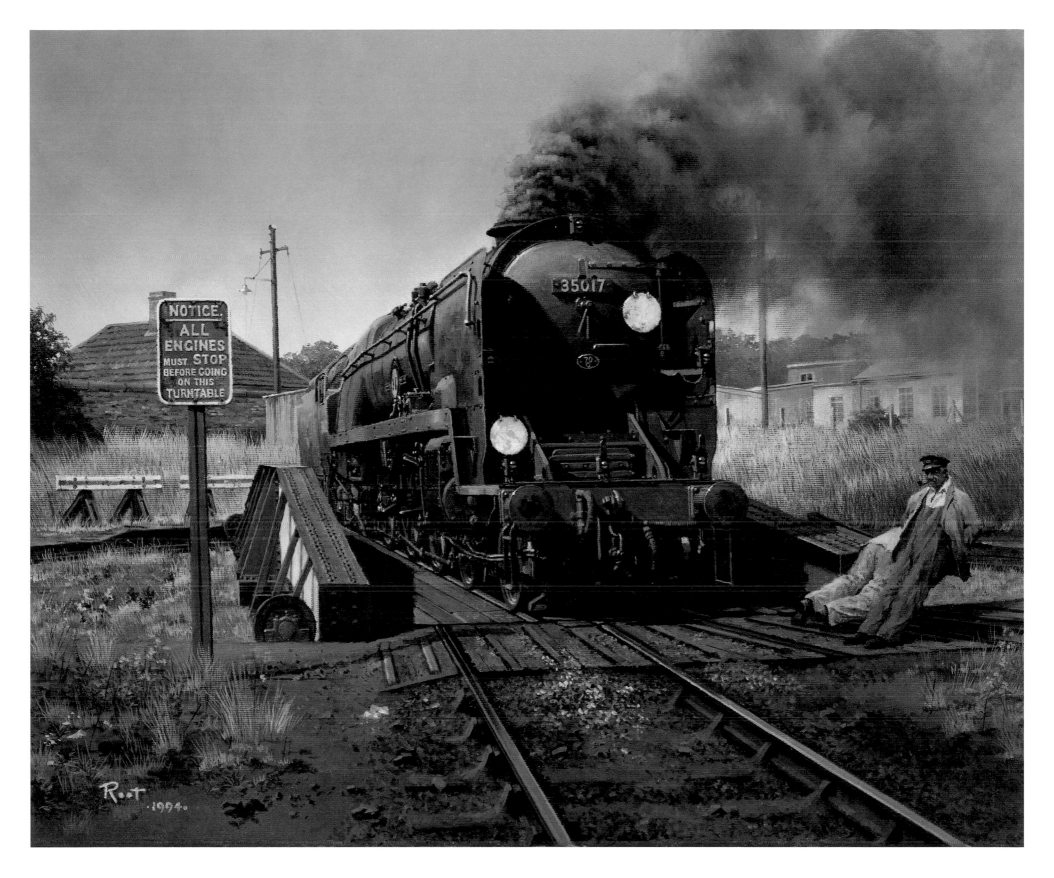

WEYMOUTH TURNAROUND

Oil on canvas, 16 × 20in (41 × 51cm), 1994
Owned by John Wright Esq

SEAFORTH HIGHLANDER

This picture was inspired by David Dickens' memories of Hartford station on the Crewe–Liverpool main line and he wanted Royal Scot No 46108 *Seaforth Highlander* to feature in the painting. It took some considerable time to find any suitable pictures of the station, but eventually some fine photographs were traced, which provided reference material for the background detail.

Hartford is a most pleasing station with some interesting features, particularly the wooden booking-hall on the road bridge above and the cast iron lattice footbridge. This bridge presented me with a few problems: because of its construction it could have easily dominated the picture, so I contrived things so that the smoke from the locomotive should blot out some of it, but not enough to obscure the background, including the signal.

I especially like the railway art of the period and the posters on the right reflect my interest in this. If one looks carefully at the one on the extreme right, it advertises Chester and shows its famous clock-bridge – Northgate, I believe.

Often I have been asked about telegraph wires in pictures and my techniques for painting them, as they were very much part of the railway scene in those days. I usually include them and use a tiny brush with very thinned-down oil paint: with a steady hand and a lot of luck it usually works – it's as simple as that!

The station at Hartford, just south-west of Northwich, Cheshire, opened in September 1837 under the auspices of the Grand Junction Railway (later absorbed into the London & North Western).

When the LNWR, in turn, became part of the London, Midland & Scottish Railway, there was a need for modern express locomotives. The result was the Royal Scot class 4-6-0s, introduced in 1927 under Sir Henry Fowler. They were rebuilt in 1943 with a tapered boiler, new cylinders, smoke deflectors and double chimney. Some would argue they assumed an even more handsome appearance in their new guise, designed by Sir William Stanier. They were employed on all the major duties on the LMS system, including being rostered for named expresses, notably those on the West Coast main line. In their latter days, they were even employed on freight duties.

The first of the class to be withdrawn went in 1962 and by 1965, only five remained in service, all based at 12A Carlisle Kingmoor. The last, No 46115 *Scots Guardsman*, lingered on until December 1965. Happily, it has been preserved, along with the doyen of the class, No 46100 *Royal Scot*. No 46108 *Seaforth Highlander*, latterly based at 12B Carlisle Upperby, was withdrawn in January 1963 and scrapped at Crewe Works some five months later.

HARTFORD.

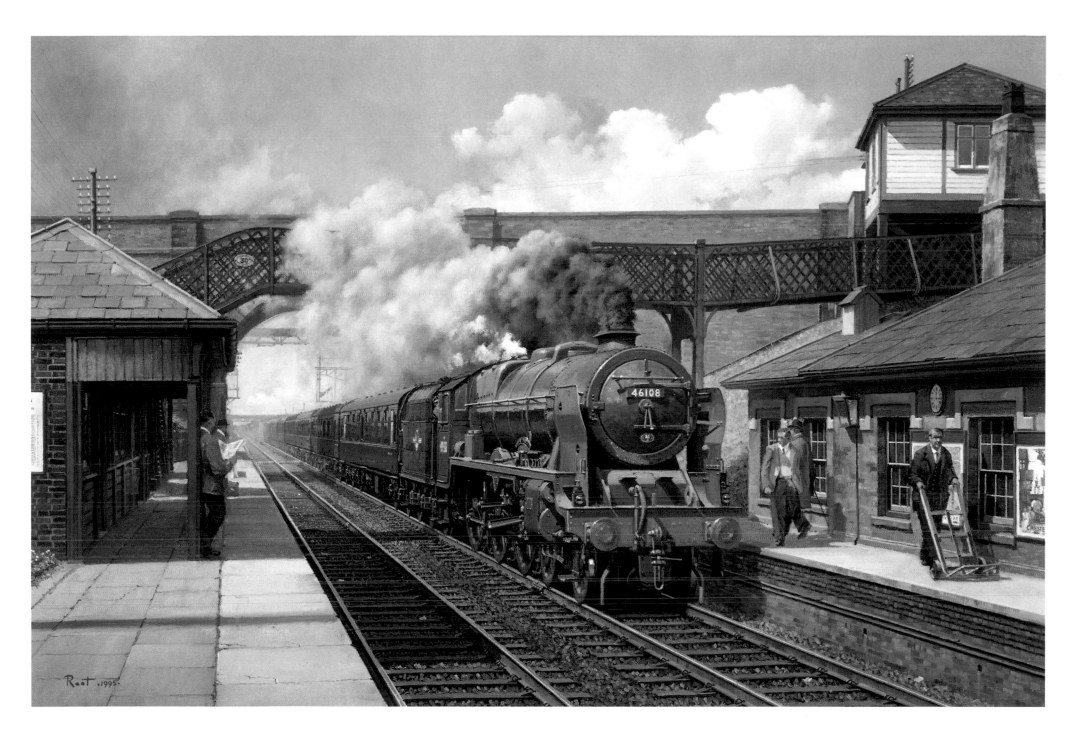

SEAFORTH HIGHLANDER

Oil on canvas, 20 × 30in (51 × 76cm), 1995
Owned by David Dickens Esq

DOVER FERRY

The brief for this painting was to portray the train ferry at Western Docks, Dover. The picture shows a Class 08 diesel shunter unloading wagons from the ferry *Eloi*, just arrived from Dunkerque. It was later reproduced in the 1988 Railfreight Calendar and is one that I was particularly pleased with.

To research the painting, I spent a day at Dover observing the comings and goings of the ferries into the purpose-built dock, making numerous sketches and taking notes. The unloading operation was most interesting, because the ship would enter the dock and the water level – as in a canal lock – would be raised or lowered so that the link span would be level with the railway track. Two Class 08 diesel shunters would then go onto the ferry together, so that an even keel was maintained. I also stayed well into the evening to get the atmosphere right for an after-dark picture. With night-time scenes it is always difficult to work out where the light falls and so when you are actually there, it makes life a lot easier.

This particular ferry was in its last year of operation and some signs of dereliction were apparent at the dock, but the painting makes it appear reasonably tidy: there were a few broken windows which were reglazed with a touch of oil paint! Shortly after this picture was done they moved to a new train ferry dock – and of course now it has been largely superseded by the Channel Tunnel, so that in less than ten years things have completely changed.

I certainly received great help and co-operation from the staff at Dover Docks and I am very grateful to Royle Publications Ltd for allowing me to use this picture in the book.

DOVER FERRY.

After some difficulties experienced in construction of the harbour facilities, the first of these train ferries from Dover's Western Docks to Dunkerque was introduced in 1936. At the same time a cross-Channel passenger service was inaugurated between London and Paris, christened the 'Night Ferry'. The first train left London Victoria at 22.00 on 14 October 1936, complete with *Wagon-Lits* sleeping cars, which were taken aboard one of the specially-built ferries for arrival in Paris around 09.00 next day. This and the other cross-Channel service obviously were suspended during the war years.

Although Railtrack officially closed the Western Docks station facility on 26 September 1994, the final loading of Railfreight Distribution wagons for the Dover–Dunkerque service took place on 22 December 1995, when Class 08 shunters Nos 08837 and 08913 were used. The ferry was the *Nord Pas De Calais*, which had been employed on the route since 1988. Since this service ceased, Western Dock has been rebuilt as a major facility for ocean and cruise liners expected to make Dover Britain's premier port, a role previously associated with Southampton.

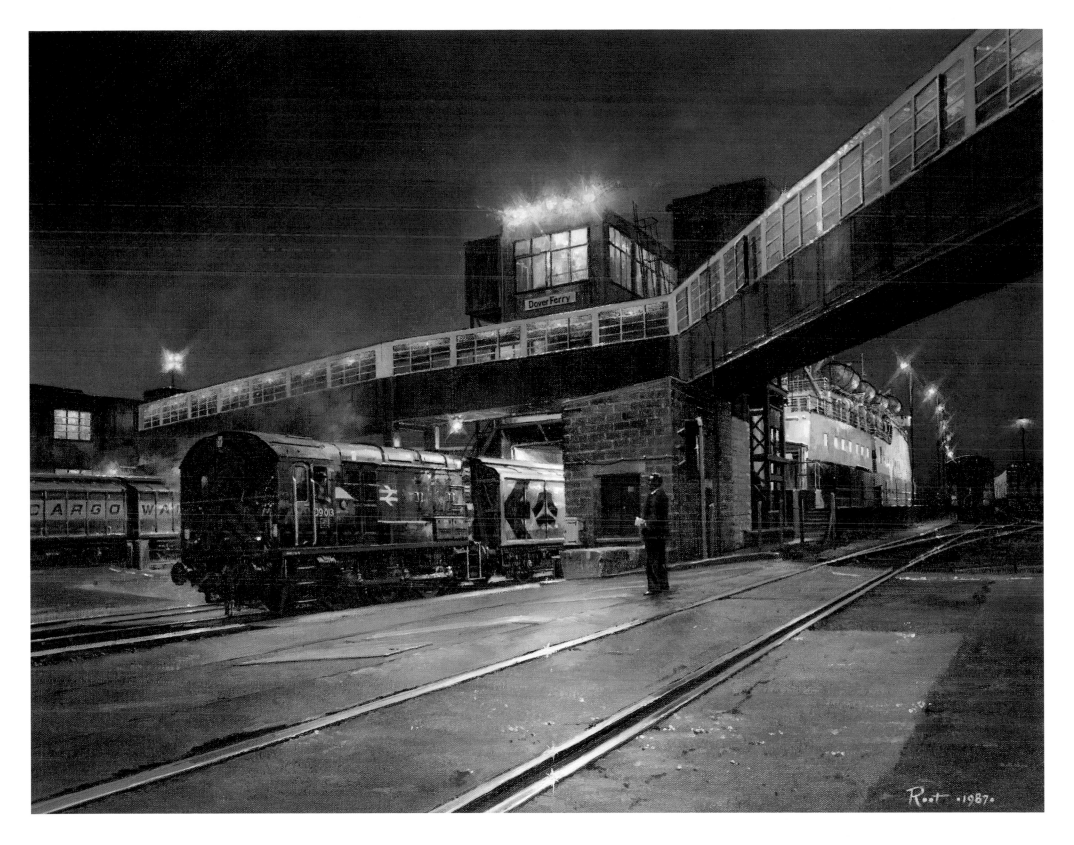

DOVER FERRY

Oil on canvas, 16 × 20in (41 × 51cm), 1987
Private collection
(reproduced courtesy of Royle Publications Ltd)

GREENE KING

No collection of my work would be complete without a picture of No 841 *Greene King*, which holds many memories for me. My association with the locomotive dates from 1972, when I worked on it at Dai Woodham's scrapyard at Barry after it was purchased by the Essex Locomotive Society – of which I was a member. It was then taken to Chappel & Wakes Colne for restoration, prior to moving on to other stomping grounds. It was coming back from one of my trips to Barry that I first met Meryl, who became my wife, so there is a strong sentimental link between this locomotive and that chance meeting. Much of my knowledge of steam engines has come from being involved with the restoration of this loco. It has been a big help with my painting to understand how they actually work: the way things move in relation to one another – especially complex valve gear – and how steam issues from various pipes, glands and so on.

I painted the picture following a conversation with a friend, who had been to the North Yorkshire Moors Railway and photographed the locomotive in an attractive setting passing under a bridge at Darnholme. I have been up there on several occasions and although the engine is no longer close to home, I like to see such a powerful machine working hard on this steeply-graded line, to which it is well suited.

Designed by Urie, the London & South Western Railway's S15 class of mixed traffic locomotive was introduced in 1920 and an initial batch of 20 built at Eastleigh Works. Under the Southern Railway, this class of 4-6-0 was developed by Maunsell and a second batch of 15 locomotives was constructed in 1927–8. A further ten were added in 1936, making a total of 45. This handsome and reliable class remained in service until the last three examples, BR Nos 30837, 30838 and 30839, were withdrawn in September 1965.

SR No 841 (later BR No 30841), one of the 1936 batch, with four others of the class, was initially allocated to Hither Green for use on goods traffic on the main line to Ashford and Dover via Tonbridge. Throughout the 1950s and early 1960s, No 30841 – working out of Exmouth Junction – became a familiar sight on the Exeter–Salisbury line. It was transferred to Feltham in October 1963 (where it had been allocated during the Second World War), but was withdrawn only four months later, in January 1964.

After rusting in the Barry scrapyard for a number of years, in September 1972 it became the 24th locomotive to depart for preservation, going to the East Anglian Railway Museum. It was named *Greene King* in recognition of a local brewery sponsor and, after restoration, took part in the Rail 150 cavalcade held at Shildon in 1975. Between October 1977 and November 1978, it operated on the Nene Valley Railway at Wansford, before moving to its current home on the North Yorkshire Moors Railway.

'EXCUSE ME'

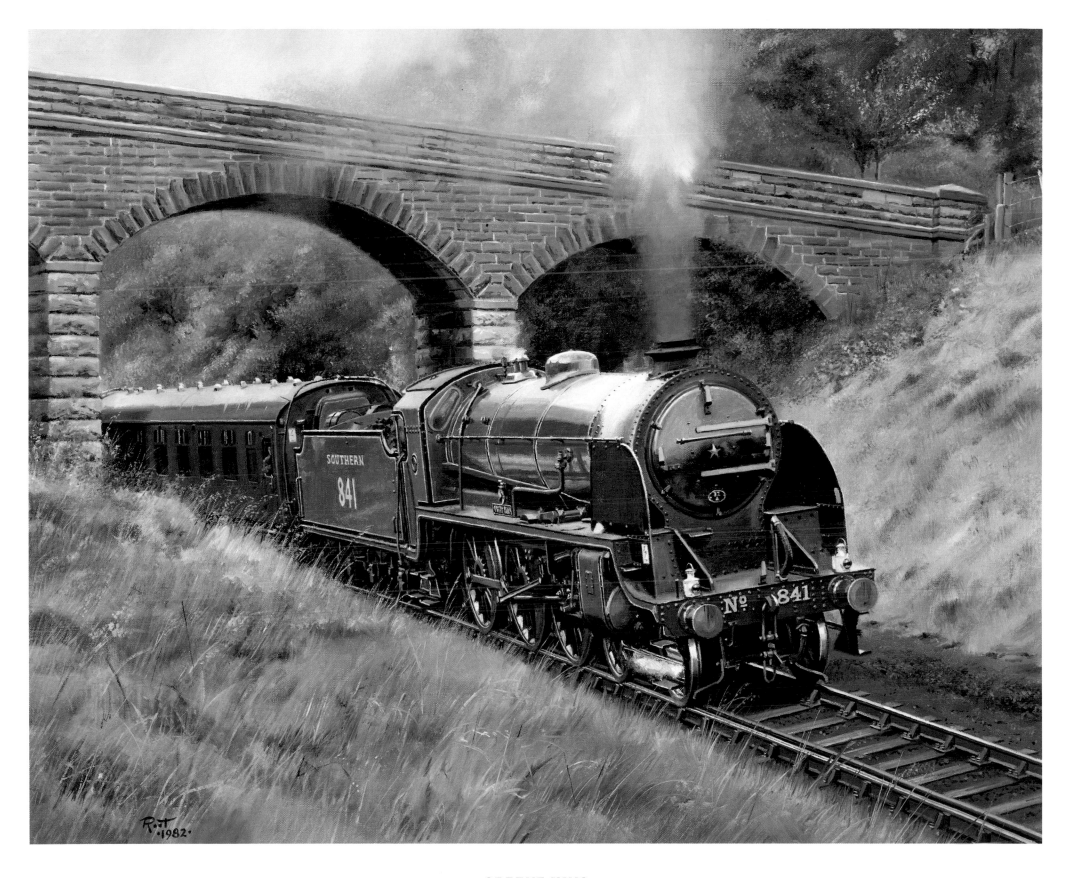

GREENE KING
Oil on canvas, 20 × 24in (51 × 61cm), 1982
Owned by Malcolm Willis Esq

31

CLOUDS AND CROSSWINDS

Greenholme, just north of Tebay on the West Coast main line, is a classic setting in which to portray a magnificent engine working hard as it climbs northwards to Shap Summit. I do prefer a low viewpoint – it shows the power of the locomotive to the best advantage, especially when it is canted slightly, sweeping round a bend.

When you have hills like those in the background, the important thing is to make use of the light and shade: you can get some lovely purples and mauves in the shadows cast by the clouds. This, combined with the rich red of the locomotive, makes for a vibrant picture. The strong crosswinds – so common on Shap – are shown well by the direction of the smoke, which invariably was blown sideways in this locality. This is one of those scenes where you can imagine that, if you were actually standing there, you would feel hot one minute and cold the next, as cloud scuds across the sun leaving you to shiver in the chilly shadows.

Although this scene is set in the late 1950s or early 1960s, I didn't visit Shap until about 1966, when on holiday in the Lake District, not far away – it was about September time, after a hot summer. Steam traction was in its death throes and there were only a few 9Fs, 'Black Fives' and the odd Britannia to be seen, but you couldn't miss the special feel for the area. What I do particularly remember on that occasion was a fairly dark sky and the straw colour of the windswept grass, which I have tried to show in this picture.

The handsome Coronation (or 'Duchess') Pacifics, designed by Sir William Stanier, were introduced in 1937 and 24 of the class were built in streamlined form. An unusual feature of the Coronations was a steam-powered coal pusher fitted in the tender.

From its first association with the 'Coronation Scot', a luxury streamlined express introduced by the LMS in July 1937 (which took only 6½ hours between London Euston and Glasgow), this powerful class of locomotive was to become the mainstay of the premier Anglo-Scottish trains on the West Coast route. They also became synonymous with hauling the 'Royal Scot', 'Midday Scot' and 'Caledonian', until diesels took over these duties. The last scheduled run over Shap by a Coronation Pacific was to haul a London–Glasgow express relief working on 1 September 1964, with No 46254 *City of Stoke-on-Trent* performing the honour.

In September 1939, No 46238 *City of Carlisle* became the 14th of the class to enter service. Between May 1946 and May 1949, the streamlining was removed from all of the Coronations thus built (*City of Carlisle* was shorn of its casing in August 1946). Resplendent in crimson lake livery, in which it was painted in June 1958, No 46238 spent its final years working out of 12B Carlisle Upperby shed until withdrawal in September 1964; it was scrapped by West of Scotland Shipbreaking Co, Troon, in December. Three of the class have been preserved: Nos 46229 *Duchess of Hamilton*, 46233 *Duchess of Sutherland* and 46235 *City of Birmingham*.

SMOKE SIGNALS !

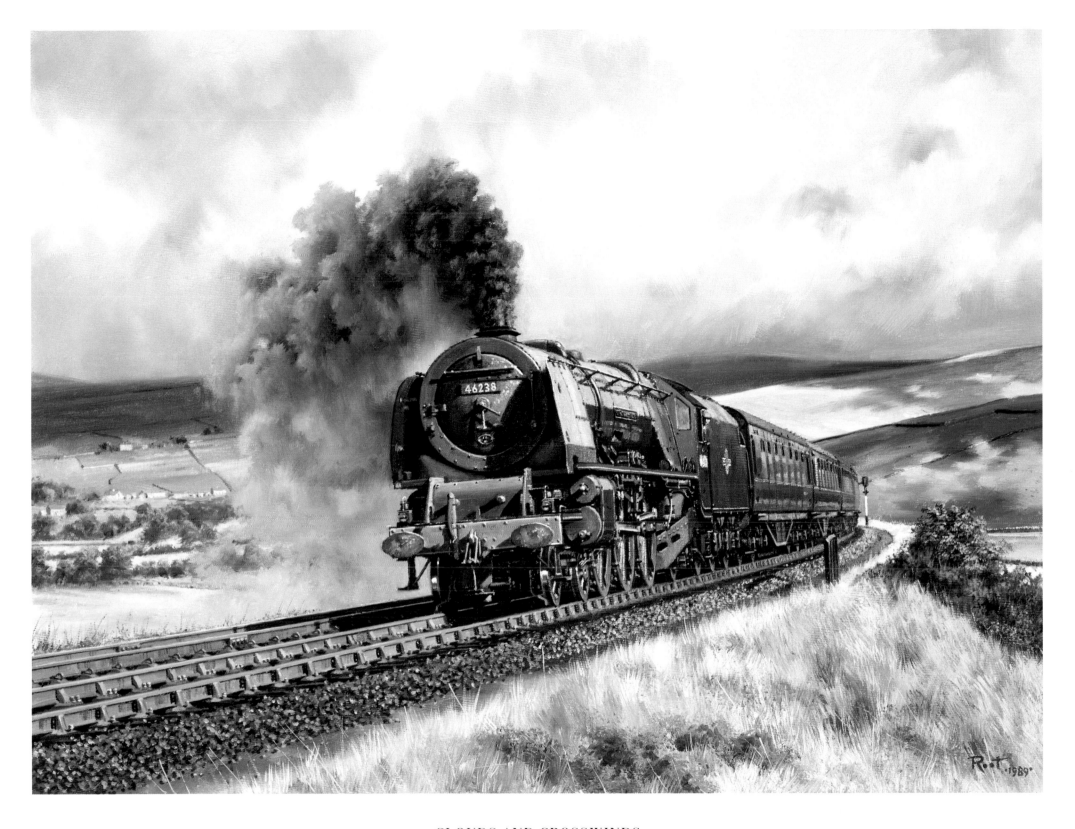

CLOUDS AND CROSSWINDS
Oil on canvas, 18 × 24in (46 × 61cm), 1989
Owned by Barry Hoper Esq

'SANDRINGHAM' SUNSET

This painting of a B17 'Sandringham' passing a J15 0-6-0 on its right was the second in a series of prints we published and it might be quite well known to some people. It is a scene I remember well, since my great-uncle was a driver at Colchester and on occasions when visiting him, we used to stand at this particular spot opposite the engine shed.

As I have mentioned elsewhere in this book, lighting is very important in a painting. Here, the suggestion of low light towards sunset is quite strong, which I hope adds atmosphere to the overall effect of what is a 'busy' picture. Certainly at the north, or country, end of Colchester station there was usually a lot of activity and, when we used to travel by train, we always looked out for locomotives standing outside the shed. Because of the confines of this motive power depot, they used to park engines in a long line and it was ideal for taking numbers as well as making general observations.

Although the station has been rebuilt and the line electrified, the lane on the left-hand side is still there and the wartime pillbox on the extreme right remains. Despite the B17 and the J15 being just a memory, if you stand at this spot now, it's not too hard to imagine how it was in the era of steam.

Colchester North station, a mile from the town centre, was once the Eastern Counties Railway's terminus, which had opened to passengers on 29 March 1843. The development of the railway and the station closely matched the town's industrial expansion and increase in population. In 1854 refreshment facilities, telegraph office and further sidings were added to the station, which was rebuilt in 1865 and remodelled in 1894. During the 1930s, the London & North Eastern Railway built platform extensions and carried out resignalling work, but this was not completed before the outbreak of war.

In 1959 electrification of the line to Clacton and London became operational. Work also resumed on the new station and was completed in 1962, with the addition of two additional through platform tracks, colour-light signals and a dive-under for down trains. The engine shed, coded 30E, closed to steam on 6 December 1959 and a new diesel depot was built, but that too has since become redundant. At 1,981ft (604m), Colchester North can boast of having the longest platform in Britain.

LNER Class B17 4-6-0 No 61667 *Bradford* was based at Colchester for a considerable time, before transferring to 30A Stratford shed in September 1957 for a few months. It ended its days at 31A Cambridge depot, from where it was withdrawn in June 1958 and broken up at Doncaster Works a month later.

COLCHESTER SHED

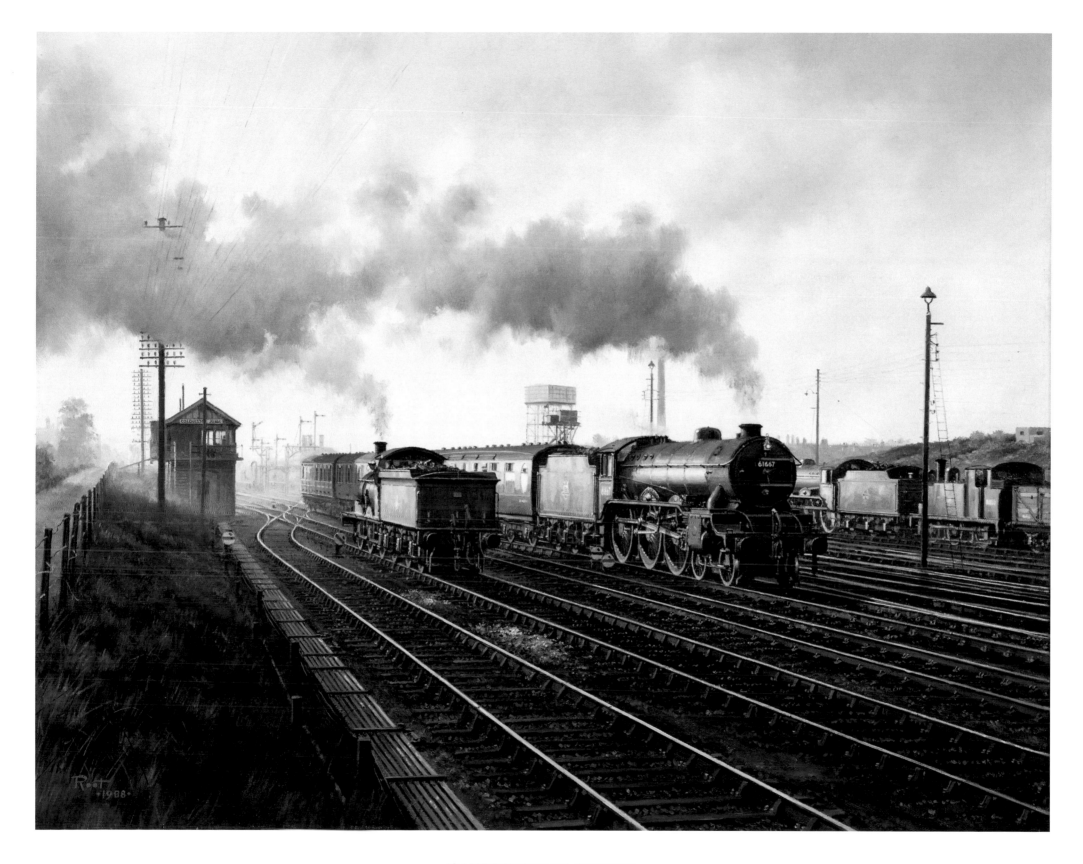

'SANDRINGHAM' SUNSET

Oil on canvas, 24 × 30in (61 × 76cm), 1988
Owned by Great Eastern Galleries

THE 'DUCHESS' AND THE CLAN

A large percentage of the pictures I am asked to do are based on people's memories: it's a way of recreating the past and this one is no exception. The figures on the left stand where my client would have done to watch trains at Farington Junction, on the West Coast main line just south of Preston.

The picture shows a 'Duchess' Pacific, *City of Manchester* with the 'Royal Scot' passing a Clan class, *Clan Cameron*, coming off the Liverpool line. The trackwork at this complex junction was quite tricky to paint and it's always difficult when you have two locomotives together – especially when viewed from an angle such as this – to get them in proportion to each other, but I was quite pleased with the result! The difference in speed of the trains is suggested by the exhaust from the Clan rising in a vertical column and that from the Duchess streaking back along the coaches, so one appears to be moving much faster than the other. There's a clear blue sky without a cloud on the horizon and it is the sort of day which would have been ideal for watching trains. I have also painted scorch marks from fires on the sides of the banks, caused either by sparks from locomotives, or perhaps by controlled burning to keep vegetation at bay.

Farington West Junction was where a spur from the Lancashire & Yorkshire Railway's Liverpool–Blackburn line once joined the London & North Western (originally North Union) Railway between Preston and Euxton Junction, in Lancashire.

The Clan class 4-6-2s were designed at Derby under British Railways and a total of ten was built – all in 1952. They were intended to replace engines of similar power on the Scottish Region, but unfortunately did not live up to expectations, being a disappointment in terms of power and heavy in coal consumption.

No 72001 *Clan Cameron* spent most of its working life at 66A Glasgow Polmadie shed and in December 1962 became one of the first five of the class to be withdrawn; it was scrapped at Darlington between October 1963 and February 1964. The last of the type, No 72007 *Clan Mackintosh*, soldiered on until December 1965, but none was preserved.

The final years of Coronation ('Duchess') class Pacific No 46246 *City of Manchester* were spent working out of 1B Camden shed, prior to which it was based at 5A Crewe North. The locomotive was withdrawn in January 1963 and broken up at Crewe Works a few months later.

'WE HAVE THE ROAD'

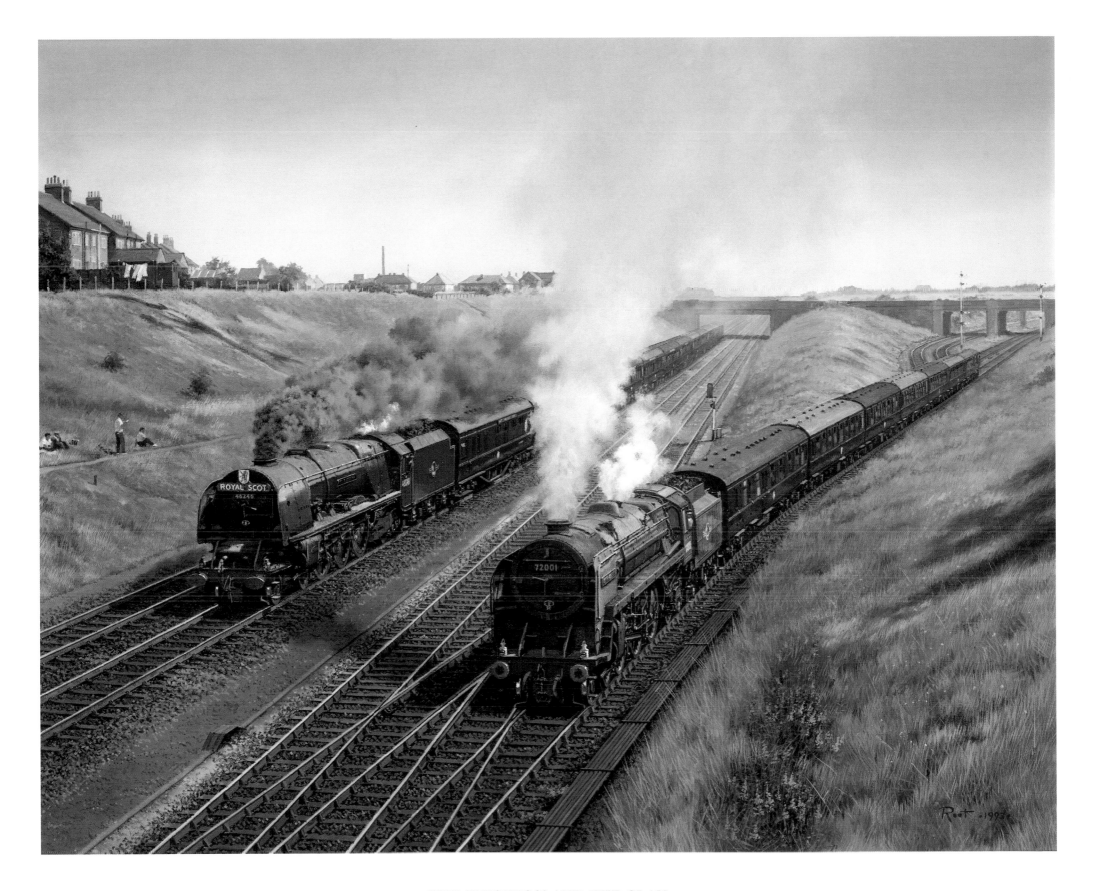

THE 'DUCHESS' AND THE CLAN
Oil on canvas, 24 × 30in (61 × 76cm), 1993
Owned by Dr Brian Edmondson

PREPARING FOR THE ROAD

This scene of a Class B1 locomotive standing outside Parkeston shed is set in the late 1940s, just prior to railway nationalisation. The depot was responsible for preparing locos on the continental trains to and from London Liverpool Street. Here the B1 is being prepared ready to haul the 'Hook Continental', arguably the most notable boat train of the time. The little tank loco just poking its nose out of the shed is a Class J69 0-6-0T fitted with both vacuum and air brakes.

There are a number of interesting features in this picture: the train the locomotive will eventually work to form the 'Hook Continental', is standing in the station in the background, seen (under the ship's raked funnel) between the water crane and its bag, which is shown to be dripping – as usual! A little further forward are two diminutive coal wagons used on the narrow-gauge railway in connection with the mechanical coaling plant on the extreme left, behind which a couple of trucks stand in an adjacent siding.

I have been told that the weather vane shown on the top of the water-treatment plant behind the shed was a 4ft-long (1.2m) bronze image of a streamlined B17 engine. Whatever happened to it when the shed closed, I don't know, but nevertheless it was an interesting feature. The little brazier by the side of the water column would often be lit in winter to keep the water from freezing.

Sited on the marshy Isle of Ray, Parkeston Quay (authorised in July 1874 and opened on 15 March 1883) took over from nearby Harwich as a port, particularly serving the Hook of Holland. Later the quay, which had seven berths, was completely rebuilt by the LNER and extended considerably, with much land being reclaimed in the process: the new station, Parkeston Quay West, opened on 1 October 1934 (and closed on 1 May 1972). From its earliest days, Parkeston was served by named boat trains and, from its inauguration on 26 September 1927, the 'Hook Continental' was one such express.

The four-road engine shed (coded 30F) remained a hive of activity until its closure to steam on 2 January 1961, and completely in January 1967. In the 1950s and 1960s, it had an allocation of ex-LMS Class 2 2-6-0s and various ex-LNER classes including B1s, K3s, J15s, J19s, J20s, J39s, J67s, J68s, J69s and N7s.

Class B1 4-6-0 No 1149 (BR No 61149) was based at Parkeston Quay until transferred to Stratford in January 1961. It was withdrawn from service in September 1962.

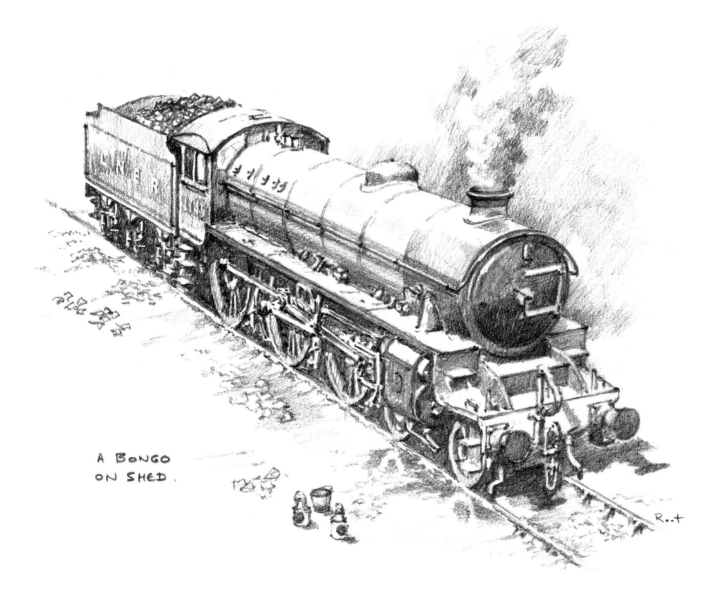

A BONGO ON SHED.

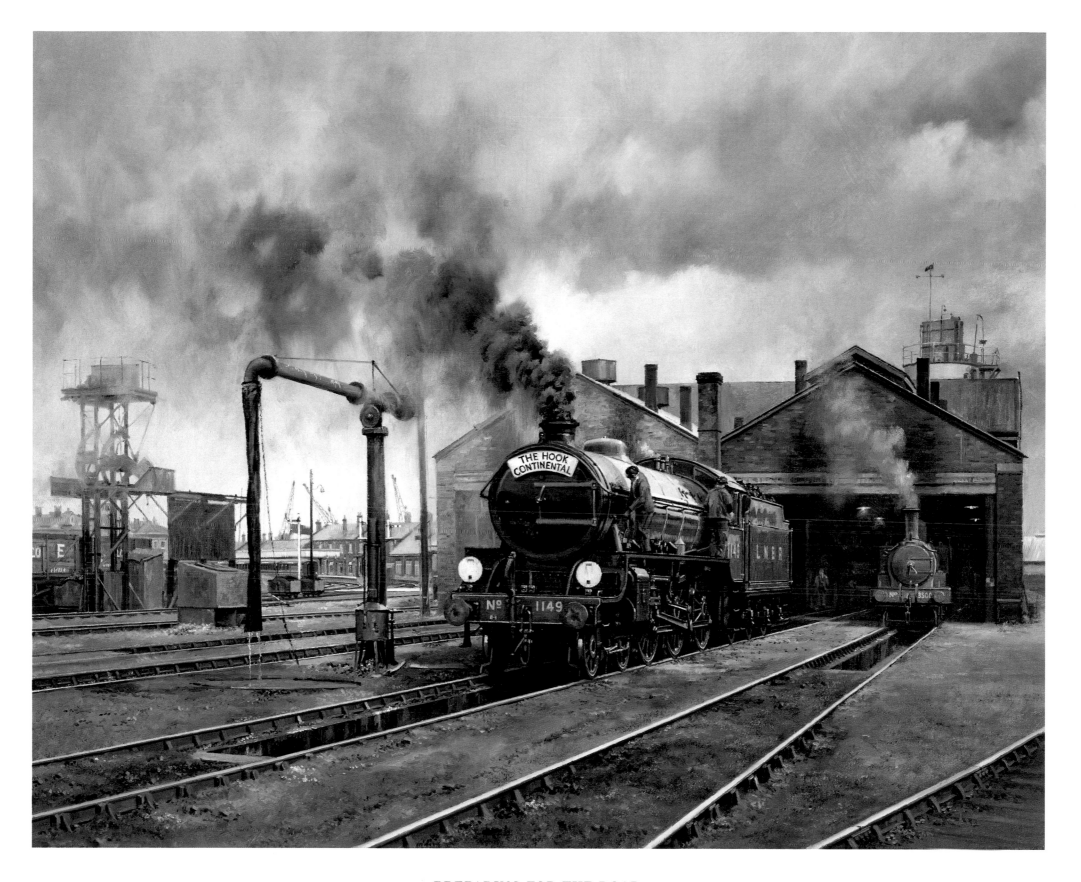

PREPARING FOR THE ROAD
Oil on canvas, 24 × 30in (61 × 76cm), 1988
Owned by Robert Clow Esq

ON TRIAL

Marks Tey is a country junction on the London Liverpool Street–Norwich main line, a few miles west of Colchester – a station I knew well and liked. I often saw and admired the Southern Bulleid Pacifics, which had undergone trials on the former Great Eastern main line in the early 1950s and – as far as I know – one was never pictured at Marks Tey, so here was a chance for me to put the matter right!

The scene shows *Boscastle*, an unrebuilt West Country class locomotive, racing towards London through Marks Tey with the 'Day Continental' – it would have built up considerable speed down Stanway Bank. The old Great Eastern crews received the Bulleid Pacifics with mixed feelings and experienced problems: the locos were not fitted with a water pickup device – there being no troughs on the Southern – and this occasionally led to unscheduled stops to replenish the tender.

What I particularly remember about Marks Tey station is that it was dominated on the down (from London) side by a signal gantry. The two tall signals for the main line were set at right angles to it and the two on the left were skewed towards the branch line. These signals are also shown to be very dirty and covered in soot from engines standing at the platform ends. In the background beyond the signal, a J15 loco is taking water, with the fireman standing in the tender making sure that everything is in order. The dark sky shows up the smoke and the steam, contrasting with the cream-coloured canopy on the right, under which two *Virol* signs are seen on the wall, advertising a product which adorned many stations in those days. One thing particularly noticeable is the long shadow in the foreground, which suggests evening light. I hope this doesn't break up the picture too much, but it does lead you into the main subject quite well.

Marks Tey, opened by the Eastern Counties Railway on 29 March 1843, was the junction for the Stour Valley line – the GER branch to Bury St Edmunds, from which the independent Colne Valley & Halstead Railway (CVR) branched off at Chappel & Wakes Colne. In the days of slip coaches, Marks Tey was a beneficiary of this service: it was a little disconcerting to see an express speed through the station to be followed a minute or two later by a single coach appearing, as if by magic, to glide to a stop at the platform! Passengers would then alight before a yard locomotive shunted the coach into a bay.

Introduced in 1946, the West Country class light Pacifics were designed by O.V.S. Bulleid primarily for use on the Southern's system west of Exeter and they proved highly successful. Their 18-ton axle loading and narrower cabs allowed them to go where the heavier Merchant Navies could not. Built in 1946, No 34039 *Boscastle* (originally SR No 21C139) was loaned to the Eastern Region in 1950/1 to conduct type trials. Allocated to 71B Bournemouth shed in November 1958, *Boscastle* frequently worked over the Somerset & Dorset line to Bath. The locomotive was rebuilt in January 1959 and remained in traffic until withdrawal in May 1965. Happily, it has been preserved and normally runs on the Great Central Railway, Loughborough.

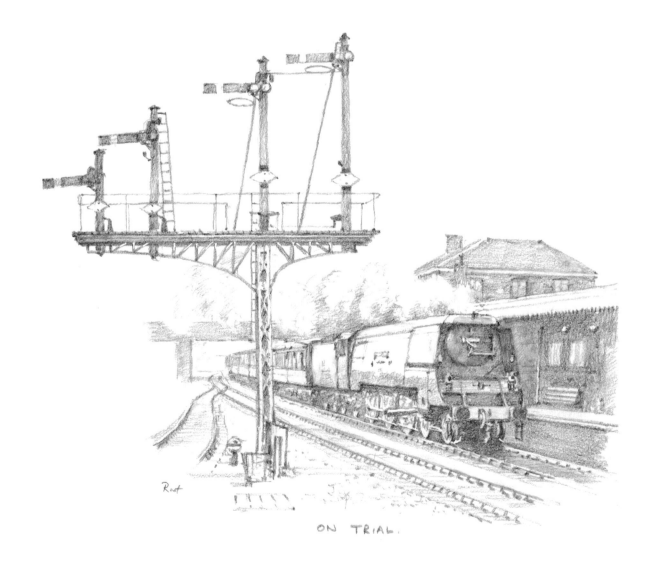

ON TRIAL.

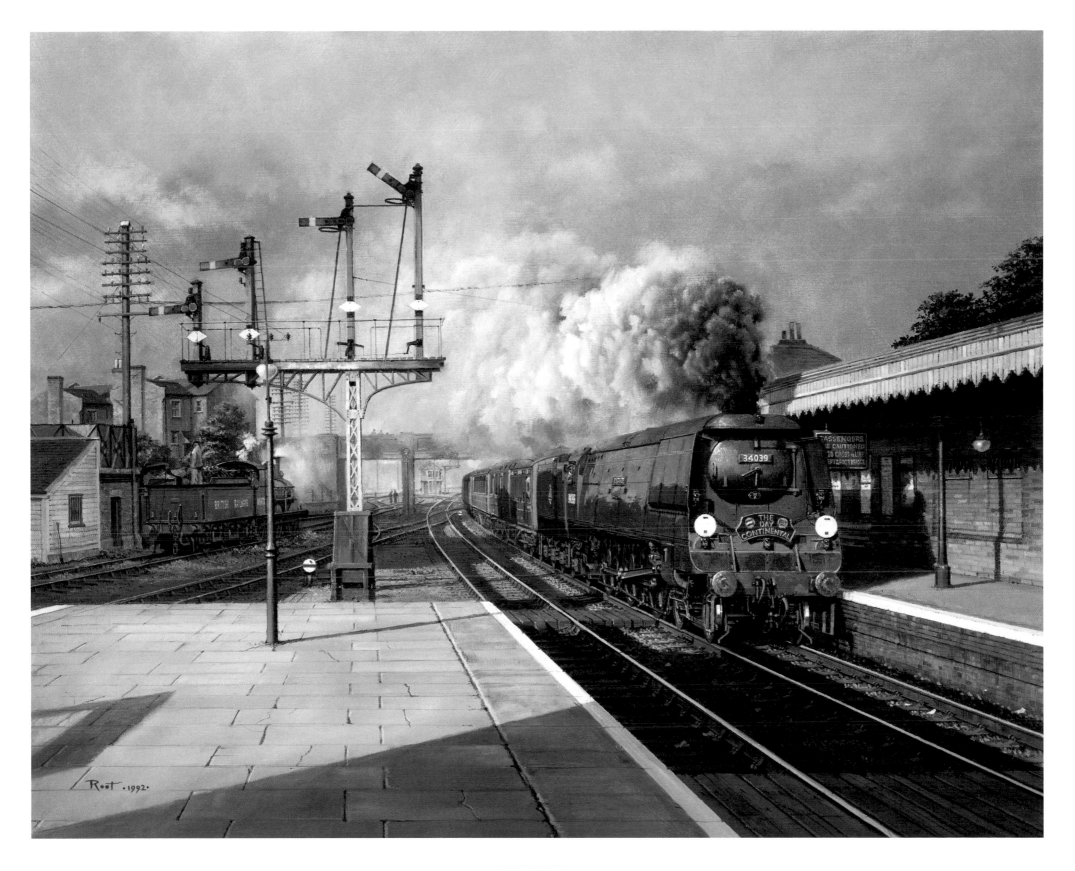

ON TRIAL
Oil on canvas, 24 × 30in (61 × 76cm), 1992
Owned by Robert Clow Esq

41

NIGHT KING

The background and the main subject are usually of equal importance in a picture – but not here: the locale is almost incidental in this painting of a train travelling through the countryside at dusk. Scenes such as this present all kinds of problems to challenge the artist, especially since the colours of objects can become totally different if the strong light of day is not shining directly on them.

In the picture, there is a stark contrast between the side of the train lit by the last glimmers of a setting sun and the front of the locomotive, which is in almost complete darkness and shows little detail. The gloom, however, is pierced by light from the two lamps on the buffer beam.

One can get some fabulous highlights on a locomotive's exhaust when it is illuminated by a low light. The orange glow reflected in the steam above the engine's cab indicates the firedoor is open and the fireman hard at work shovelling coal. The grass on the right is half in light and half in deep shadow, as are the telegraph poles, suggesting that the sun is almost over the horizon; but there's just enough light to see that the livery of the Mark 1 coaches is the wonderful chocolate and cream adopted by BR Western Region in emulation of the GWR. Although challenging to paint, what I've tried to create is essentially a very simple picture: just an imaginary BR scene on an ex-GWR main line.

Designed by C.B. Collett and introduced in 1927, the King class were the most powerful 4-6-0s ever built in Britain. Along with the slightly smaller Castle class, they were the mainstay of the crack GW/WR expresses until the end of the summer service in 1962. They mostly worked the Bristol, Wolverhampton and Plymouth routes from London Paddington on expresses such as the 'Cornish Riviera', 'Mayflower', 'Bristolian', 'Cambrian Coast' and 'Inter City'. In the early 1960s, a few were based in South Wales at Cardiff Canton and worked the 'Red Dragon' and 'Capitals United' express trains.

A total of 30 locomotives was built and the most famous, No 6000 *King George V*, went to America in 1927 to participate in the centenary of the Baltimore & Ohio Railroad celebrations. The locomotive, which is now preserved, still carries the bell it was presented with to mark the occasion. Between September 1955 and March 1958, all of the class were fitted with double chimneys; this improved their performance but, in some people's eyes, not their appearance. The highest speed recorded for a King class engine was 109mph (174.4kph), achieved by No 6015 *King Richard II* – coincidentally the first to receive a double chimney.

No 6005 *King George II* spent its final years working out of 84A Wolverhampton Stafford Road depot before transferring to 81A Old Oak Common in October 1961. It was withdrawn in November 1962 and scrapped at Cashmore's, Newport, in August 1963. The last four to remain in service were withdrawn in December 1962. Besides No 6000, a further two examples have been preserved for posterity; they are No 6023 *King Edward II* and No 6024 *King Edward I*.

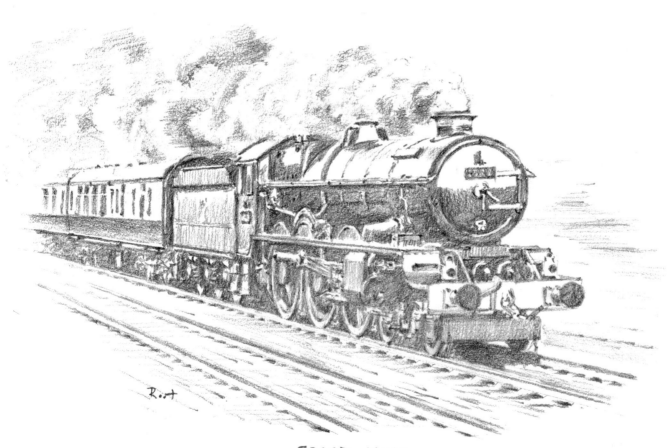

SPEED KING

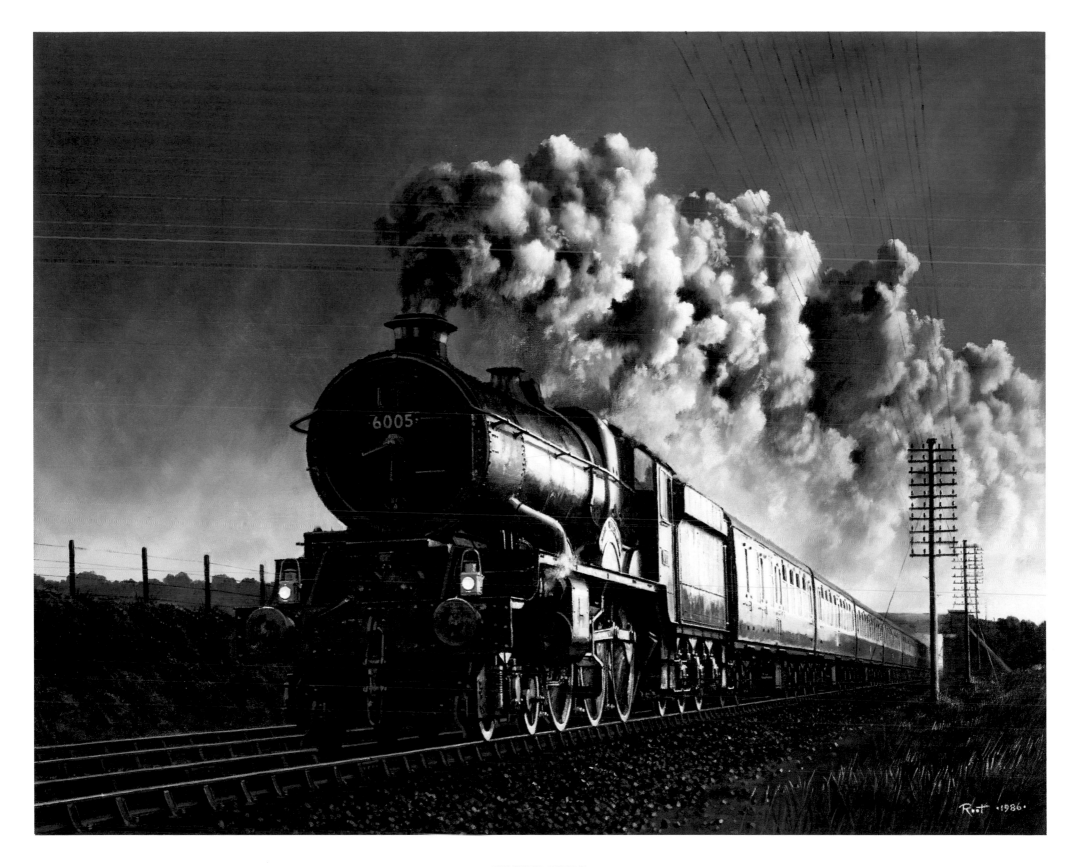

NIGHT KING

Oil on canvas, 24 × 30in (61 × 76cm), 1986
Owned by John Smith Esq

HALSTEAD'S OWN

Ioriginally painted this picture of Halstead station purely for my own pleasure, having always lived in the town and been interested in the Colne Valley Railway, in northern Essex. It was a particularly fascinating line, remaining independent until the major grouping of 1923, and even had its own engines as well as locomotive works here, where minor repairs were carried out.

The locomotive is No 2 *Halstead*, a Hawthorn Leslie 2-4-2 tank – very similar to the Great Eastern 2-4-2 design – which had adequate power for the small trains that operated on the Colne Valley. The engines were painted in an attractive black livery with red and white lining and the initials of the railway in gold on each side. However, the coaching stock was a mixed

bag – the company buying what they could, mostly secondhand, from other railways.

In this scene, showing Halstead as it would have appeared in Edwardian days, there's a lot of activity with a number of people waiting on the platform, including a gentleman in a bowler hat and with a rolled newspaper under his arm, who appears to be chatting to the crew of the locomotive. The style of the 'perambulator' in the foreground is markedly different from that of today! The blue enamel signs were very much a feature of the time – particularly that for *Suttons Seeds* – as was the gas lamp. The tall signal seen over the top of the canopy was constructed that way to make it visible to trains coming from the Chappel & Wakes Colne direction.

Numerous pledges by the Eastern Counties Railway to construct branches in East Anglia often came to nothing: this included an extension from their Witham and Braintree line to Halstead and Sudbury which, they announced, would be presented in the 1846 parliamentary session. However, the same year, the Colchester, Stour Valley, Sudbury & Halstead Railway was incorporated on 26 June to build a line from the ECR at Marks Tey to Sudbury – a distance of 12 miles (19km), with a 5¾-mile (9.3km) branch from Chappel to Halstead, a notable silk-weaving centre. The Sudbury line opened on 2 July 1849 and was extended to Long Melford on 9 August 1865 – but no branch was built to Halstead.

With Halstead still without a station, local residents took matters into their own hands: the Colne Valley & Halstead Railway was incorporated and an Act of 30 June 1856 authorised a line to be built from Chappel to Halstead. After a difficult two years spent raising the necessary funds, construction finally commenced on 16 February 1858. The formal opening of the 6 mile 2 chain (9.7km) line took place on 16 April 1860. An extension to Haverhill – at that time still without a railway – was started on 19 June 1860 and opened in stages: initially to Castle Hedingham, then to Yeldham, the first train reaching Haverhill on 10 May 1863. Later a connection was made at Haverhill to the Great Eastern's Sudbury–Cambridge line on 9 August 1865. The Colne Valley & Halstead Railway remained independent until the major grouping of 1923, when it was absorbed into the London & North Eastern Railway.

Locomotive No 2 *Halstead*, a 2-4-2 tank, was built in 1887 by Hawthorn Leslie (maker's number 2079) and acquired by the CVR the same year. Renumbered by the LNER as 8312, it remained in service until 1930.

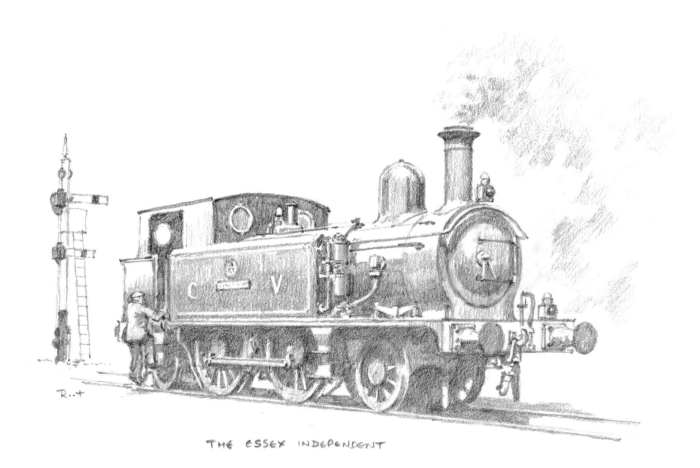

THE ESSEX INDEPENDENT

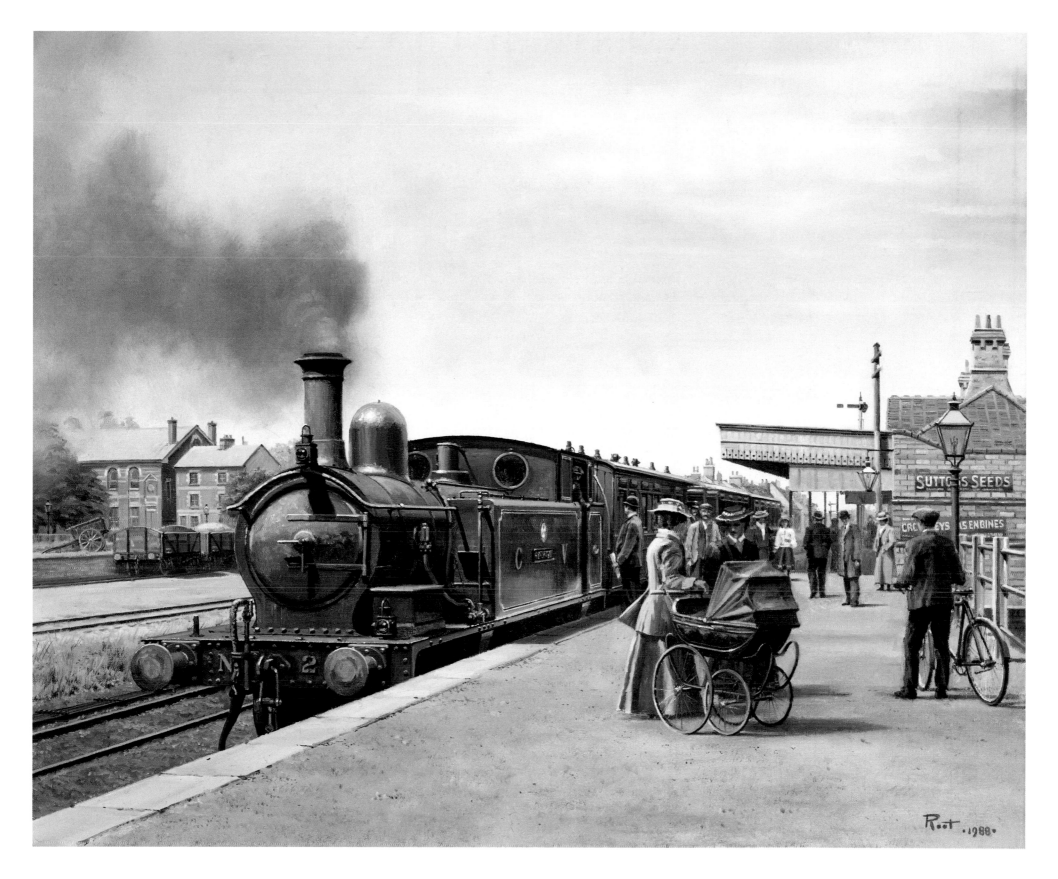

HALSTEAD'S OWN
Oil on canvas, 20 × 24in (51 × 61cm), 1988
Owned by Alan Robinson Esq

45

A GARDEN VIEW

Over the years I have taken a lot of stick about painting mostly East Anglian scenes, so I thought that it would be good to include this picture of a Castle class locomotive in South Wales, which may help to mollify members of the Great Western fraternity who might think their interests are under-represented! It's also a chance to show I do paint a wide variety of subjects for clients.

This picture was painted for a gentleman whose view from his back garden in Cardiff is depicted here. To me it seems to be every train enthusiast's dream to be able to wander down the garden in the evening and to watch the trains go by – infinitely better than watching TV! This painting was done in the more unusual way of a train crossing from left to right, giving an almost side-on view. However, it was done purposely to show the aspect of the railway as seen from this particular garden and would be the actual perspective if you stood there and watched trains pass by.

The prominent building on the right was the Cardiff Arms, owned by Brain's, a family-run brewery. What a combination: trains passing your back garden and a pub within easy distance – pure heaven! It is gratifying to include a painting which contrasts totally with all those set in open landscape. This one typifies an urban view, with rows of terraced houses backed onto a railway – the sort of thing you see on a train journey through a town or city. It's not necessarily a pretty picture, but one with which I am pleased and holds fond memories for its owner, thus fulfilling the object of the exercise.

PIT STOP

The 'Capitals United Express' was one of a number of named trains introduced by the Western Region of British Railways and it ran between London Paddington and Cardiff in South Wales. The picture represents a typical scene in the summer of 1958, when the train left the English capital at 15.55, arriving in the Welsh capital at 18.53. It went via Reading, Swindon, Badminton, the Severn Tunnel and Newport, to Cardiff – a distance of 145 miles (233km).

Castle class 4-6-0 No 5078 *Beaufort* was based at 86C Cardiff Canton shed from June to December 1958, when it was re-allocated to 82A Bristol Bath Road depot. After at least two further transfers (and being fitted with a double chimney in December 1961) it ended its days at 87A Neath shed before withdrawal in November 1962 – a year which saw no fewer than 55 of the original 167 members of the class taken out of service. *Beaufort*, built in May 1939, was one of 12 of the class to be renamed in January 1941 by the Great Western Railway after famous Second World War aircraft. The locomotive had covered 1,038,165 miles (1,670,511km) before it was broken up at Swindon Works in April 1963.

A GARDEN VIEW

Oil on canvas, 24 × 30in (61 × 76cm), 1989
Owned by Roger K. Hurford Esq

47

CHRISTMAS GREETINGS

This picture was painted for a Christmas card – hence the title – and depicts a Thompson B1 4-6-0 leaving the goods junction at Parkeston Quay in Essex. The apparently incomplete signal gantry on the left-hand side was a particular feature here and the signal box which controlled it can just be seen over the middle of the goods train. The long shed in the background was on the west quay, which many ex-servicemen will remember because they often departed from or arrived back in Britain here, either during wartime or in the days of National Service. The quay, which had been built on reclaimed land, is no longer open.

In the painting the railway workers on the left-hand side are greeting the footplate crew of the B1 as it passes with a long freight train of mixed imports. The weather is horrendous, with a gale blowing and snow falling heavily. The 'Father Christmas' touch is a robin sitting on a signal wire in the bottom right-hand corner – but, unlike the late Terence Cuneo's trademark, a mouse, you won't find one in any other picture of mine, so there's no point in looking!

Freight through Harwich and, even more so, Parkeston Quay, opened in 1887 further up the River Stour, provided the railway with a much-needed source of revenue. Trade grew steadily over the years, with the exception of the 1930s depression, and the railway was successful in retaining much of this port traffic. In 1964 alone, it handled 328,754 tons (334,030 tonnes) of freight, 28 per cent of which was food and drink, with agricultural produce making up a further 20 per cent of the total.

This amount of trade encouraged British Rail to announce on 18 May 1966 an investment of £8 million, which included the provision of new maintenance workshops and two 30-ton cranes. By 1968, this made Parkeston Quay one of the most modern and highly-mechanised ports in the world, capable of handling containers as well as car traffic and passengers for Europe. Further storage and container-handling facilities were added to the port over the ensuing years and in the early 1970s the platforms at Parkeston Quay were lengthened to accommodate boat trains, which permitted the closure of West Quay station on 1 May 1972.

Although road traffic has taken much of the railway's trade, particularly over the last quarter-century, in the 1990s Parkeston Quay still handles considerable freightliner traffic, now competing with Felixstowe for this trade.

GOODS JUNCTION

CHRISTMAS GREETINGS
Oil on canvas, 12 × 16in (30 × 41cm), 1992
Owned by Robert Clow Esq

HORNET'S BEAUTY

One of the handsome Class A2 Peppercorn Pacifics, *Hornet's Beauty*, is shown at a particularly beautiful location between Mawcarse and Glenfarg in Scotland, a setting made famous by the late W.J.V. Anderson, the well-known railway photographer. There were many very scenic railway locations such as Shap, Dainton and Beattock and although this is less well known, I think it is outstandingly attractive and offers plenty of scope for the artist.

It's an evening light, which I especially like painting, and it casts a deep shadow on the bank in the right foreground, as well as on the hillside in the distance; however, it's strong enough to highlight the side of the handrails on the locomotive and emphasises the red and cream of the coaching stock. This is another one of those pictures where one argues the case whether telegraph poles should be put in or not; I think on this occasion they are appropriate and don't intrude in any way, or take one's eye from the main subject.

The former North British Railway's Edinburgh–Perth route was completed on 4 May 1890 when the line opened between Mawcarse and Hilton Junction (where it joined the Caledonian Railway 1 mile 2 chains south of Perth). This followed the opening of the Forth Bridge and the NBR's expansion northwards, during which they absorbed the Devon Valley Railway through Rumbling Bridge and Dollar. This meant the NBR could also offer an alternative to the Caledonian Railway between Glasgow and Perth and they advertised their service as via 'the picturesque route'. Although a double-track main line, the Mawcarse–Hilton Junction section was particularly testing for southbound trains: the six-mile stretch between Bridge of Earn and Glenfarg had a ruling gradient of 1:75 and two notable tunnels. The Cowdenbeath North Junction–Hilton Junction line closed on 5 January 1970 and today has largely been obliterated by the M90 motorway.

Introduced in 1947, the Class A2 Pacifics were a Peppercorn development from the A2/2s (a Thompson rebuild of the original Gresley Class P2 2-8-2s) and 15 were built in this form. The whole class – comprising A2/1, A2/2, A2/3 and A2 variants from mixed origins – totalled 40 (Nos 60500–60539), but all were extinct by December 1966. No 60535 *Hornet's Beauty* was based at 64B

Edinburgh Haymarket shed during the late 1950s and early 1960s. It was transferred in October 1961 to 64A Edinburgh St Margarets, finally moving to 66A Glasgow Polmadie in October 1963, before withdrawal in June 1965. Only one Class A2 Pacific has been preserved: No 60532 *Blue Peter*, one of the last to remain in BR service. Now privately owned, it is restored to main-line working order.

PEPPERCORN PACIFIC

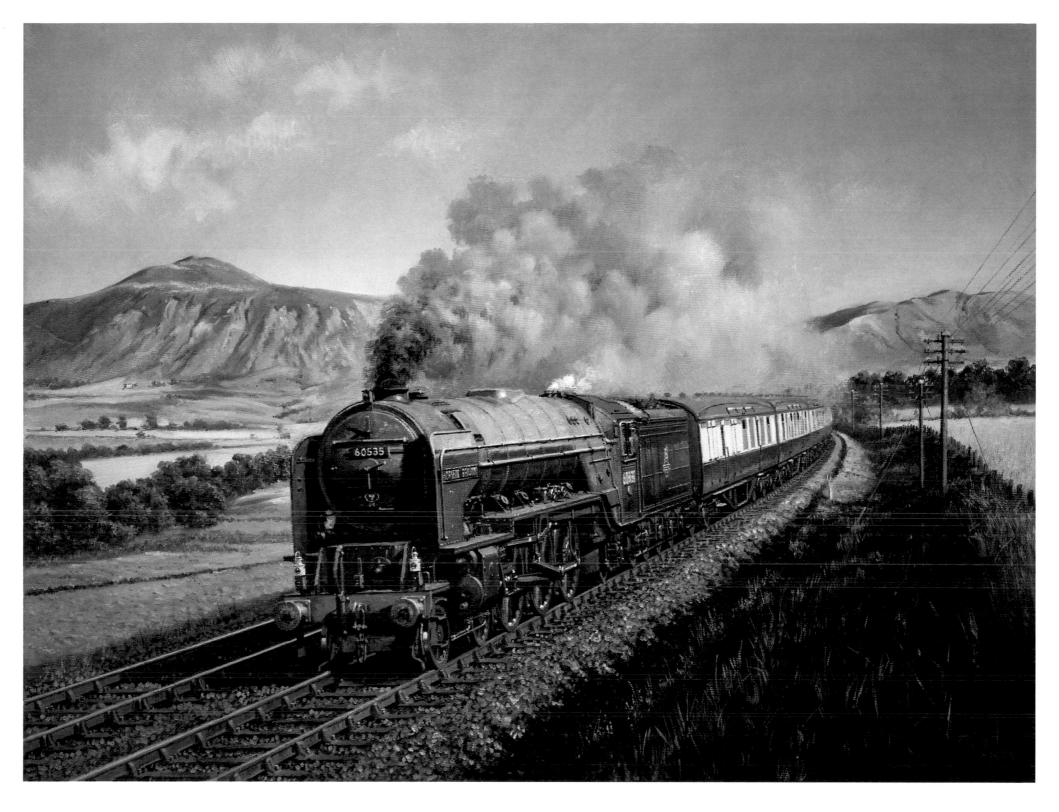

HORNET'S BEAUTY

Oil on canvas, 18 × 24in (46 × 61cm), 1989
Owned by Eric Pearce Esq

A 'DUCHESS' AT DILLICAR

One of the most scenic stretches on the West Coast main line was the Lune Gorge and its water troughs at Dillicar, near Tebay in Westmorland. The picture shows a Coronation Pacific taking on water before tackling the arduous climb of Shap as it heads northwards with an express for Scotland. It was painted for a gentleman who wanted one of the later 'Duchesses', *Sir William A. Stanier FRS*, shown in a superb setting. What better than this one – and with the River Lune alongside the line!

I have tried to incorporate as many colours in this picture as is possible. The maroon livery of the 'Duchess' is enhanced by the oblique lighting, which catches the side of the loco's boiler and reflects the blue of the sky on its casing: the green and the mauvy-blue of the shadows cast by clouds on the hills are further contrasting hues.

When locomotives passed over troughs, they usually left a trail of water on the wooden boards either side of the track and the reflection by this is shown in the picture. As a child I can remember watching on television the *Interlude*, which was a series of very short films between the main programmes. The 'Potter's Wheel' was one example, but I seem to recall there was another which featured water troughs and showed trains passing over them and how they refilled. I found it fascinating at the time, although I didn't realise they had to be on a dead-level track!

Being one of the few level stretches of the West Coast main line in the northern hills, Dillicar, in the Lune Gorge, was ideal for locomotives to replenish their water supplies on the ascent or descent of Shap. The northbound climb of Shap from Tebay was particularly demanding for locomotive crews; however, the beauty of the Lune Gorge through which they passed was not usually lost on them. The painting shows the shadowy north face of the 1,325ft-high (404m) Birk Knott (along the side of which runs the A685 road) looming over the train. On the left, the slopes of Brockholes Bank on Tebay Fell rise above the sparkling River Lune – excellent for sports fishing – weaving its serpentine course through the gorge.

In 1947 Coronation Class 8P 4-6-2 No 46256 *Sir William A. Stanier FRS* was the last of the class to be built at Crewe under the auspices of the LMS, when H.G. Ivatt was still Chief Mechanical Engineer. Together with No 46257 *City of Salford*, the final example (completed after nationalisation), the locomotive was fitted with roller bearings and had various detail differences from the other 'Duchess' Pacifics, including a redesigned trailing pony truck. Painted in crimson lake livery in May 1958, *Sir William A. Stanier FRS* was based at 5A Crewe North shed prior to withdrawal in October 1964, a date which coincided with its sister locomotive, *City of Salford*, working from 12A Carlisle Kingmoor.

QUENCHING THE THIRST.

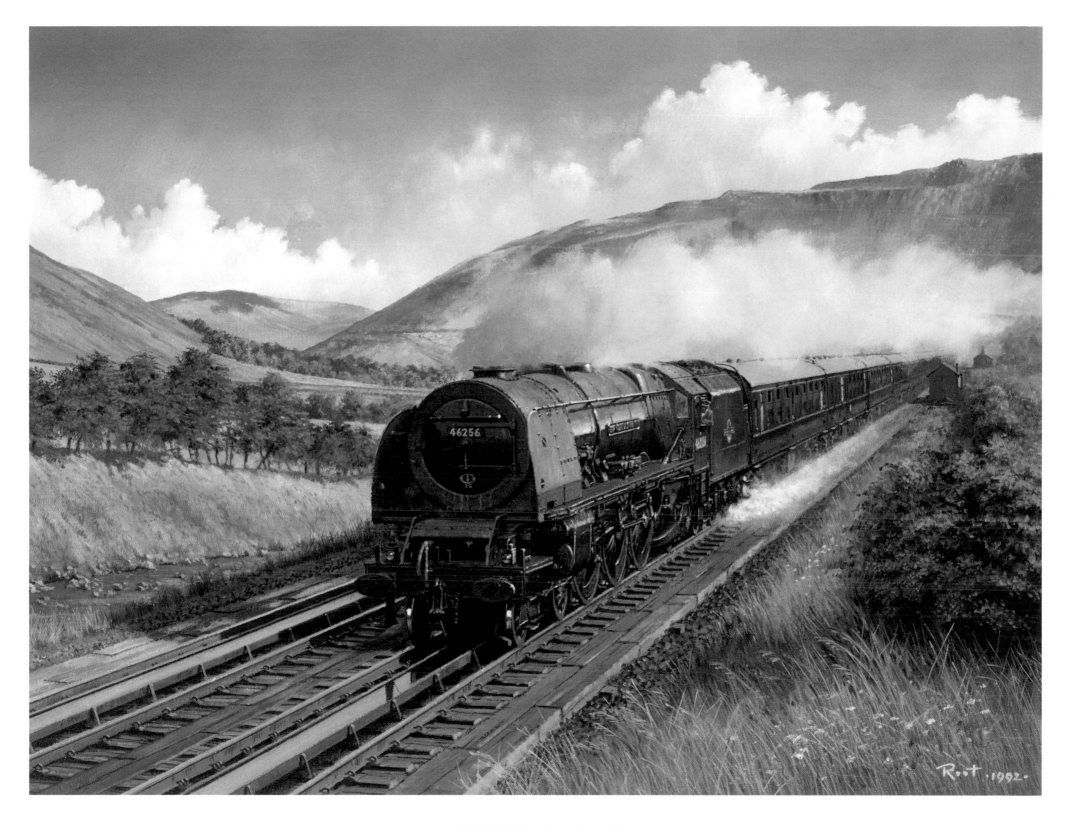

A 'DUCHESS' AT DILLICAR

Oil on canvas, 18 × 24in (46 × 61cm), 1992
Owned by David Dickens Esq

EVENING LOCAL

In this painting a Class D16, or 'Claud Hamilton', locomotive is shown on a local train from Sudbury arriving at Chappel & Wakes Colne on the Stour Valley line in Essex. Chappel was the junction for the Colne Valley line, the points and signal for which are in the distance near the bridge. In the days when the Colne Valley was an independent railway, it had its own siding that extended from behind the signal box to the bridge. It was a typically attractive little branch-line junction and East Anglian station.

The afternoon light and long shadows, with clouds building up in the distance, suggest it is one of those days when you are not sure if it is going to remain sunny or rain and whether to take your jumper off, or to put on something waterproof! In the shadows a bicycle nestling against the wooden store-box on the left is a reminder that it was often the main mode of transport to and from work in those days, rather than the car. The white line on the edge of the platform is something I remember well: it always looked neat and tidy when standing on the station, but when you looked over the edge down to the track, you could see how the paint had dripped in unsightly streaks!

Chappel is now the site of the East Anglian Railway Museum. The signal box is still there – as is the Stour Valley line – and the former goods yard is where exhibits for the museum are now kept.

Although the Colchester, Stour Valley, Sudbury & Halstead Railway was incorporated in 1846 to build a 12-mile (19km) line from Marks Tey to Sudbury via Chappel, the latter station was opened on 2 July 1849 under the auspices of the Eastern Union Railway and in turn became part of the Great Eastern Railway, incorporated on 7 August 1862. The station, renamed Chappel & Wakes Colne on 1 October 1914, remains open on the branch from Marks Tey to Sudbury, which is now the terminus, since the line to Bury St Edmunds shut on 10 April 1961 and the line to Cambridge via Haverhill closed on 6 March 1967.

D16/3 4-4-0 No 62576 was one of the 'Claud Hamilton' locomotives rebuilt by Gresley in the 1920s from J. Holden's original design for the Great Eastern Railway, introduced in 1900 (in BR days D16 No 62546 still carried the name *Claud Hamilton*). By the 1950s these elderly engines were mainly confined to secondary duties in East Anglia and almost at the end of their working days. No 62576 was based at 31A Cambridge shed for the last few months of its service, which ended in September 1957. It was scrapped at Stratford Works a month later. The last of the class, No 62613, was withdrawn on 25 October 1960; none was preserved.

WATCHING THE LOCAL

EVENING LOCAL

Oil on canvas, 20 × 24in (51 × 61cm), 1993
Private collection

SCARBOROUGH BY STEAM

The painting's owner photographed Jubilee class *Bahamas* on 17 June 1973 and his picture formed the basis of this composition. The locomotive was working a day trip from Manchester to Scarborough, which was steam-hauled only between Guide Bridge and Sheffield.

It is shown about to enter the two-mile (3.2km) Cowburn Tunnel in the High Peak district of Derbyshire.

The maroon of the engine and coaches makes a pleasing contrast with the surrounding greenery on the embankments and the stonework of the impressive bridge. The train on this occasion was actually made up of British Rail blue and grey stock, but to match the LMS livery of the loco, I made the coaches crimson lake too. Being a preserved engine, *Bahamas* was very clean and the reflections are all very bright and sharp on its gleaming boiler casing. Under the bridge, the shadows falling on the coach suggest the actual position of the train, whilst the angle of brick wall on the left-hand side helps lead the eye to the main subject.

Introduced in 1934, the handsome Jubilee Class 6P 4-6-0s, designed by Sir William Stanier for the London, Midland & Scottish Railway, were a highly successful class of locomotive and developed from the Patriot 4-6-0s. They were employed on both main line expresses as well as fast freights, many of their numbers remaining in service for well over thirty years. One example, No 45637 *Windward Islands* was involved in the Harrow & Wealdstone disaster on 8 October 1952 and was damaged beyond repair, along with Princess class No 6202 *Princess Anne*. Particularly during the 1950s and 1960s, the Jubilee 4-6-0s were to be seen working everywhere from Scotland to Somerset in the south-west of England. They were allocated to a wide number of sheds in the London Midland, North Eastern, Scottish and Western regions of British Railways.

Built in 1935, No 5596 *Bahamas* (BR No 45596) spent its final eleven years in BR service working out of 8A Liverpool Edge Hill, 12B Carlisle Upperby and 9B Stockport, where it was allocated in July 1962. It was withdrawn in July 1966 and stored at Stockport until September 1967, before being purchased for preservation. Today it normally resides on the Keighley & Worth Valley Railway, West Yorkshire, and is in main line running condition. Three other examples have been preserved: BR Nos 45593 *Kolhapur*, 45690 *Leander* and 45699 *Galatea*.

A BREATH OF FRESH AIR.

SCARBOROUGH BY STEAM
Oil on canvas, 24 × 30in (61 × 76cm), 1990
Owned by Tom Boustead Esq

'WINDCUTTER'

Some would say the 'Austerity' 2-8-0 and 2-10-0 locomotives were ugly, but they were genuine workhorses and very much a part of the railway scene. One is shown here on the old Great Central line heading towards New Basford station, having just emerged from Sherwood Rise Tunnel on the northern outskirts of Nottingham. This picture illustrates the power of a steam engine and is basically about smoke.

The environmentalists might have something to say about it today, but the painting shows how exhaust from a steam loco drifts out of a tunnel's portal, as it might have done for several minutes after the last wagon had passed through. The grimy locomotive is shown working hard on a typical loose-coupled freight, which inevitably banged and clanged its way along – especially if the guard in the brake van was a little dilatory in his duties. Subjected to copious amounts of smoke over the years, the cliffs in the cutting became ingrained with soot and it was difficult to tell their true colour.

When I am painting smoke, I tend to apply the oil paint in blocks of colour and leave it about an hour or two, until it's just starting to set, and then work the brush over the canvas to merge it into a soft pattern. During one very hot summer, I went back to a painting after the allotted time to find the 'smoke' had set solid and had to start all over again – it was the only occasion when hot weather worked against me!

AUSTERITY POWER

Rated as Class 8F, the War Department, or 'Austerity', 2-8-0 freight locomotives were robust if somewhat basic. They were designed by R.A. Riddles for the Ministry of Supply and were introduced in 1943 in response to the chronic shortage of engines during the Second World War. They were generally unpopular with footplate crews because of their rough-riding qualities and nicknamed 'bed-irons', due to loud clanking noises that emanated from the motion! The 'Austerities' were mainly used on heavy freight workings all over the BR system, with the exception of the Southern Region. For much of the 1950s and up until the mid-1960s, WD 2-8-0 No 90437 worked out of 38A (from 1 February 1958 coded 40E) Colwick shed before being transferred in December 1965; it was withdrawn in April 1966 from 36A Doncaster.

The Great Central main line was renowned for its fast loose-coupled freight workings between Annesley in Nottinghamshire and Woodford Halse in Northamptonshire. The easy gradients and superb engineering of the GC line made it possible for these freights to achieve an average speed close to 50mph, thus earning the name 'windcutters' or 'runners'. It was a fine service providing steady revenue for the railway.

This, sadly, was to no avail for the Midland Region, who had assumed responsibility for the GC line in 1958, gradually diverted traffic to the Midland main line. Dr Beeching's axe issued the *coup de grâce* in September 1966 and the GC line closed as a through route from London Marylebone to Sheffield Victoria; only small sections of it remain today. Sherwood Rise cutting has been partially backfilled and a substantial modern housing development has swallowed up the GC's formation, to within almost 50yd (46m) of the tunnel's northern portal.

'WINDCUTTER'

Oil on canvas, 30 × 24in (76 × 61cm), 1985
Owned by Tom Boustead Esq

59

DAMP AND DESERTED

An elderly Class J15 0-6-0 locomotive arrives at Yeldham, one of the little stations on the Colne Valley line in Essex and which is seen to be damp and deserted – any passengers would have been sitting in the shelter! It was very small with a tiny booking office, but had all the usual paraphernalia normally associated with stations. I enjoy painting 'wet-look' pictures and would like to think this one came off quite well. The gap between the signal box and the train lends itself nicely to reflecting the paintwork of the coaches onto the platform edge. Water lying on the platform surface highlights its unevenness. I have to admit it's very much a matter of trial and error to achieve a wet look in a picture: you keep adding colours and moving them around with the brush until you think it 'looks right' – there's no easy answer really!

There's all sorts of detail to note in the picture, such as the totem and station sign, the gas lamp, colourful posters and the shed where people would have left their bicycles. These are a few of the things which typify a country branch-line station of the time.

Yeldham station, on the Colne Valley & Halstead Railway in Essex, opened on 26 May 1862. It was sited on the south side of the village of Great Yeldham (between Haverhill and Halstead) and, like many other country stations of the time, it would probably have been staffed with a station-master, a porter-cum-shunter and perhaps two signalmen working on a shift basis. If lucky, their association would be long and harmonious, offering a life full of riches – not in money, but of a quality and contentment which in today's world would seem idyllic and far removed from reality. For several generations a job on the railway was usually one for life . . . and then along came Dr Beeching.

The main station building was basic and constructed mainly of wood with a slate roof, but topped with a fine chimney. The booking office was flanked by two smaller corrugated-iron and timber structures, added in 1907; and there was a sizeable brick shelter in the middle of the platform. A substantial brick-and-timber goods shed on the east side of the line was served by a short siding. By the level-crossing, the brick-built signal box, which also controlled the small yard, was a solid-looking affair with a slate roof. Although two tracks ran past the platform, one was a siding and the passing loop for trains was just beyond the northern end of the station. The last timetable published by the CVR on 9 April 1923 showed seven trains in either direction calling at Yeldham each weekday. By 1960, this had been reduced to four up and five down trains. Yeldham station closed on 1 January 1962.

R..t

THE TRAVELLING BANK MANAGER!

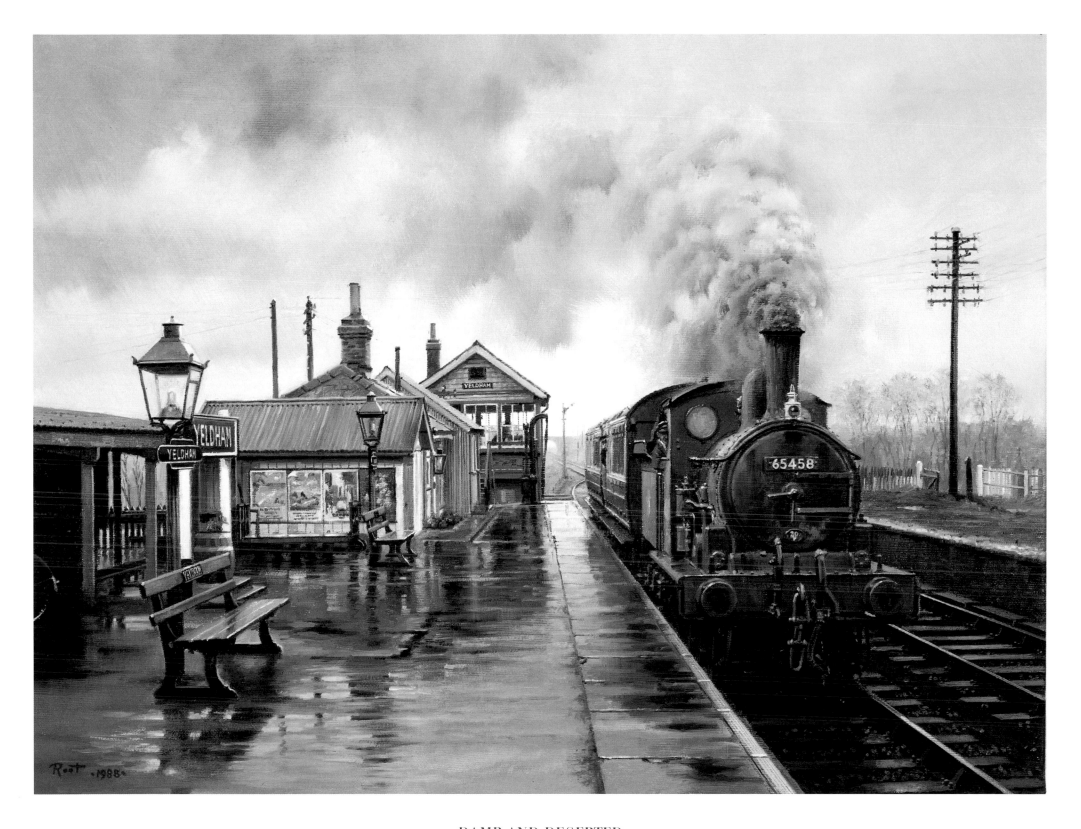

DAMP AND DESERTED

Oil on canvas, 18 × 24in (46 × 61cm), 1988
Owned by Ronald Hutley Esq

SNOW ON THE SETTLE

Birkett Common in Cumbria is the setting for this picture. It shows the preserved Midland Railway Compound No 1000 and LMS Jubilee No 5690 *Leander* battling against the elements in atrocious conditions on the Settle & Carlisle line. In what was quite a difficult task for the locomotives, they are seen working very hard with a long train of blue and grey Mark 1 coaches, as well as cream and brown Metro-Cammell Pullmans. The picture was painted for its owner as a reminder of the event, which was in the earlier days of railway preservation and I think it's

also a tribute to the people involved to have been able to run a train such as this (the testing S&C continues to attract similar steam workings).

One might assume that snow should be painted pure-white, but in reality you can use lots of colours and shades. It is broken up not only by the dry-stone walling, but also the tufts and blades of grass on ridges in the fields – which always seem to stick out of the snow. By way of contrast to the starkness of the railway lines and stone walls, the background just disappears into a grey, murky haze and merges with the sky.

The Settle & Carlisle line was dubbed the 'Long Drag' by railwaymen, and with good reason: the gradients were long and fairly steep, which were a severe test for both man and machine. With open cabs, footplate crews were afforded little protection from the elements, which could be extremely harsh – especially the constant wind. The locomotives in the painting are shown on an embankment as they climb the 1:100 gradient heading southwards towards Birkett Tunnel; there would be another five miles (8km) to go to the summit at Ais Gill.

Built in 1902, No 1000 was one of the class of 4-4-0 three-cylinder Compounds designed by S.W. Johnson for the Midland Railway and later rebuilt by R.M. Deeley. After long and illustrious service, No 1000 was one of the first locomotives to be restored to full working order by the British Transport Commission. It was treated almost with reverence: a decree issued by the authorities stated that coaling was to be done by hand, supposedly to avoid the risk of damage that shovels might inflict on the paint and metalwork! The locomotive is now part of the National Railway Collection at York. Jubilee class *Leander* normally resides on the Severn Valley Railway at Bridgnorth, Shropshire.

CLASSIC PAIR.

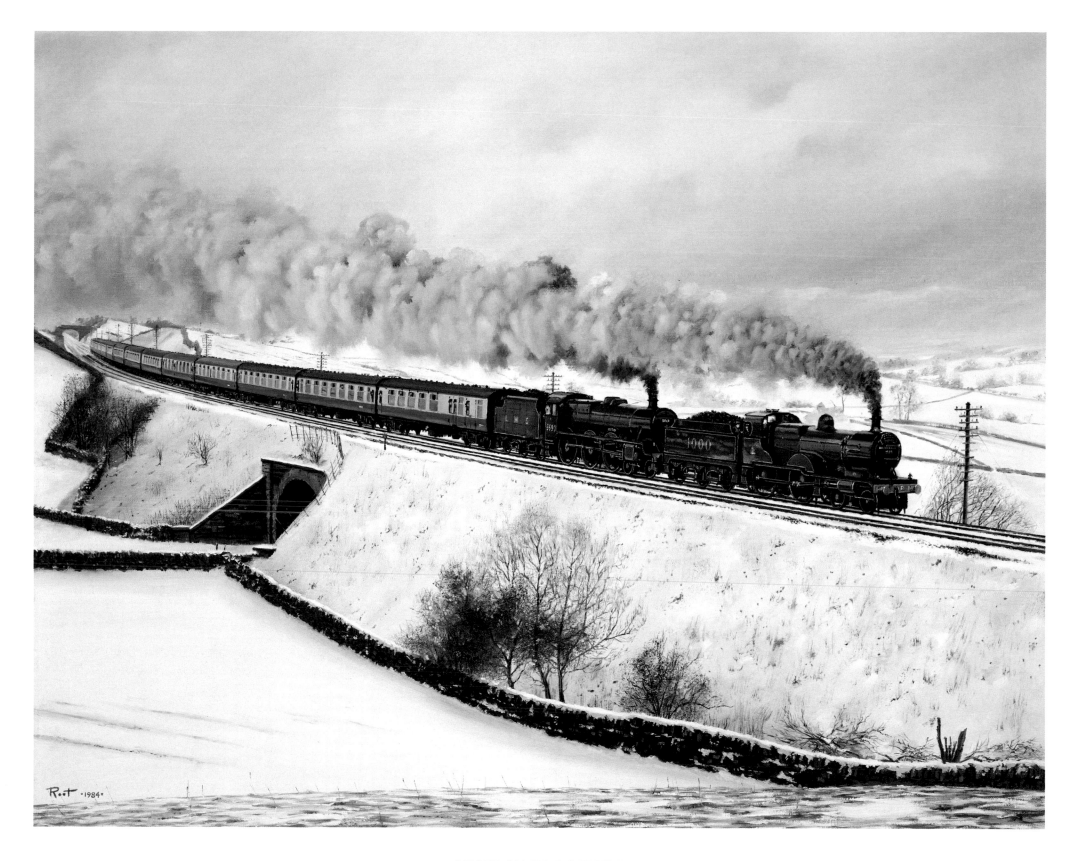

SNOW ON THE SETTLE

Oil on canvas, 24 × 30in (61 × 76cm), 1984
Owned by John Smith Esq

A HELPING HAND

Approaching Scotchman's Bridge at Greenholme on the West Coast main line just north of Tebay, a really grimy and work-stained Class 9F 2-10-0 is being rendered assistance by a Class 4 2-6-0 on the climb to Shap Summit. It is in the late afternoon or early evening, offering a lovely low sun to highlight the side of the engine and wagons. Low light also tends to make railway lines appear a rich browny-orange colour, which looks good. There are some nice shadows which steal across the wind-blown grass in the foreground and tend to give a bit of movement to the picture. The stone walls are characteristic of this area and help make it a much stronger picture.

Although the engine is thoroughly dirty, it's surprising what colours you can use to achieve that effect: the white limescale down the side boiler casing might give an impression of many years of arduous work, although in this case – being a locomotive built in the 1950s – not so many! The lenses of the lamps on the front of the loco are blue at the top and a yellowy colour at the bottom. This is a combination I often use to suggest glass; similarly, these colours tend to work nicely on the treads of the wheels where they are very shiny.

THE POWER OF STEAM

The herculean exploits of the Tebay bankers employed on Shap are legion: these engines assisted heavy northbound trains on the $5\frac{1}{2}$-mile (8.9km) climb. They would be attached to the rear of trains at Tebay, where the gradient commenced at a moderate 1:146, but steepened to 1:75 for the final four miles (6km) to the summit, 916ft (279m) above sea level. For many years this task was ably performed by Fairburn Class 4 2-6-4 tanks, until the last three of the type were withdrawn from Tebay in May 1967. For several years these powerful engines had been supplemented by Ivatt Class 4 2-6-0s and then, in the final few months of steam traction, BR Class 4 4-6-0s. One of these was used on the last train to be banked to Shap Summit on 31 December 1967. Tebay shed (coded 12E) closed to steam from 1 January 1968.

BR Class 9F 2-10-0 No 92014 was withdrawn in October 1967, having spent its final few years working out of 8H Birkenhead shed. The locomotive was broken up at Buttigieg's, Newport, between March and August 1968. The BR Standard Class 9F freight locomotives were first introduced in 1954, having been designed at Brighton by R.A. Riddles for British Railways. They were both highly successful and popular engines and were equally at home hauling expresses as well as freight trains. The last examples survived almost until the end of steam in the summer of 1968. Nine have been preserved, including the last steam locomotive to be built at Swindon for BR, No 92220 *Evening Star*, now part of the National Collection at York.

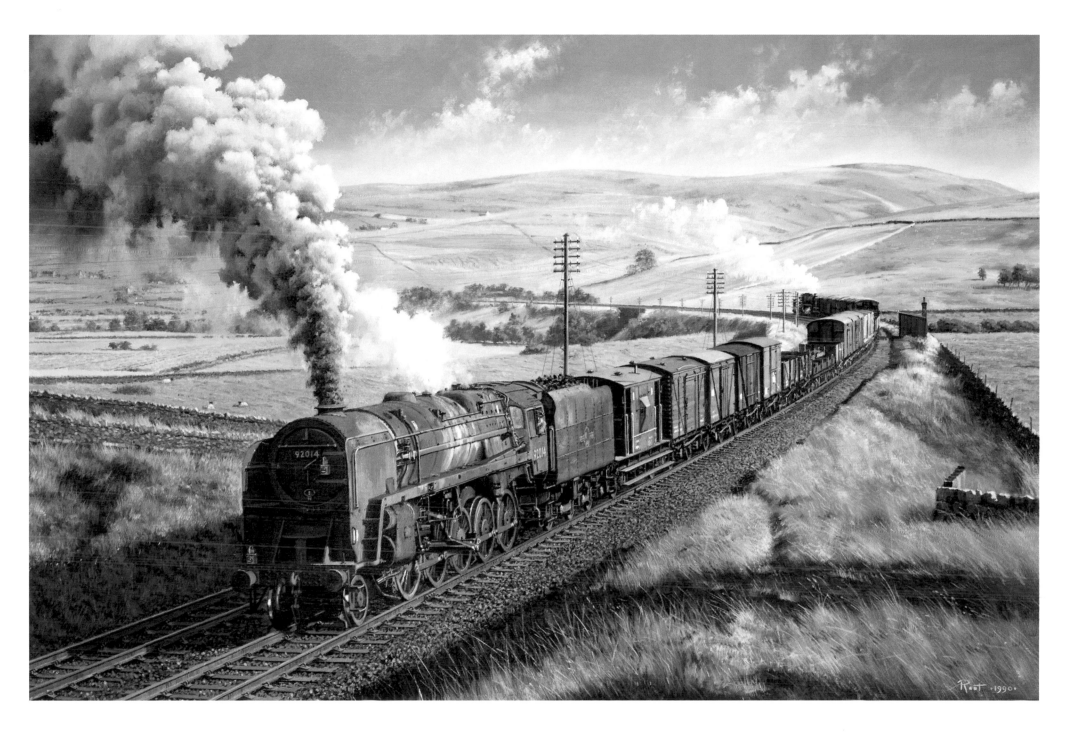

A HELPING HAND

Oil on canvas, 20 × 30in (51 × 76cm), 1990
Owned by David Dickens Esq

RHYTHM AND BLUES

This early 1950s scene of Winchester shows a blue-liveried Merchant Navy class Pacific pounding up the 1:252 gradient towards the station. I can remember the distinctive rhythmic sound of these three-cylinder machines as they tore through the station on their way to London Waterloo. Three elegant brick-built bridges spanned the railway in a deep cutting at the south end of the station and, with the line disappearing to a point in the far distance, they help make a superb perspective and striking picture.

The signal on the left I remember well: when it was lowered, the lattice post shook noticeably and the signal arm bounced (the white patch on the bridge behind was painted to aid drivers' distant vision of it). I can recall that this bridge was a particularly good vantage point to watch trains from and I stood there for many a happy hour! I have very fond memories of Winchester and I think one tends to put much more into a painting when one has a strong feeling for a particular place.

Merchant Navy class 4-6-2 No 35005 *Canadian Pacific* was built at Eastleigh Works in 1941 and originally carried the Southern Railway number 21C5. The design of the three-cylinder Bulleid Pacifics was innovative in several ways, but not without its problems: the chain-driven valve gear, totally enclosed in an oil bath, was to prove the locomotives' Achilles heel. The chain stretched in service affecting the valve timing; also the oil bath leaked, causing the engines to slip badly and occasionally to catch fire! The slab-sided boiler cladding was described by O.V.S. Bulleid as 'air-smoothed' and not streamlined: it was meant to aid cleaning and also to be compatible with his coaching stock. Smoke clearance was very much the subject of trial and error until a satisfactory design for the casing was settled upon.

In the end the Merchant Navies' problems were solved by substantially rebuilding them in the late 1950s. *Canadian Pacific* (rebuilt in May 1959) was latterly based at 70G Weymouth shed before withdrawal in October 1965; but it was spared the cutter's torch. Following a lengthy restoration during the late 1980s and early 1990s, it is now in superb working order and runs on the Great Central Railway at Loughborough.

Southern steam on the London Waterloo–Bournemouth–Weymouth route came to an end in July 1967 and also marked the demise of these powerful and revolutionary locomotives. Fortunately, no fewer than 20 West Country/Battle of Britain and 11 Merchant Navy Pacifics have been preserved.

R..t

MOTION

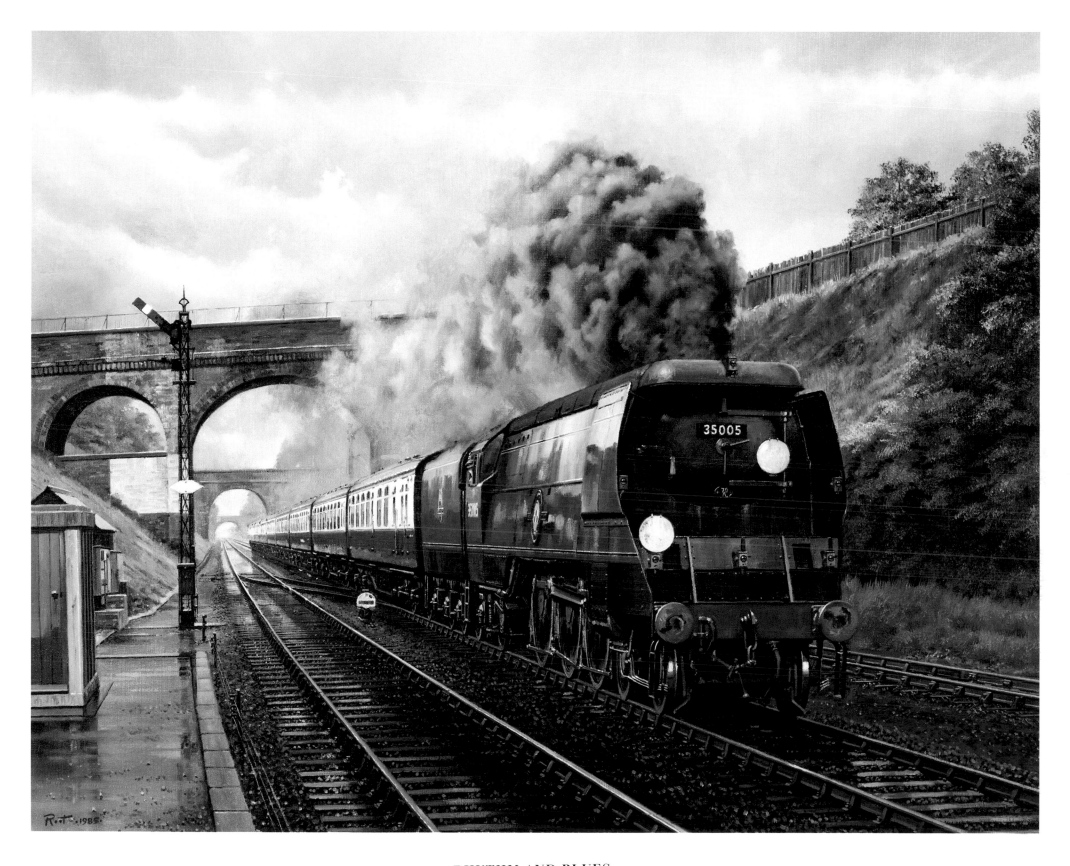

RHYTHM AND BLUES

Oil on canvas, 24 × 30in (61 × 76cm), 1985
Private collection

STREAKING PAST

The owner of this painting commissioned it as a reminder of his days as a young lad when he went trainspotting at Cadwell just north of Hitchin in Hertfordshire (he is the one in the yellow short-sleeved shirt). It is supposed to be one of those ideal days when you sat by the lineside in the hot sun and watched the trains go by. It was essential to position the figures so that details like the name of the signal box and the locomotive's wheels were not obscured.

I do like this picture: the slightly unusual angle of the loco becomes a feature of the painting and the reflection of light on the side of the A4 is excellent for giving a convincing impression that it is really made of metal. The Gresley coach just behind the loco reminds me that dirt and grime always used to stick to the beading and crevices on these vehicles – even after they had been through a wash – and often remained there for years until the cream went almost a dark brown colour. I remember how green paint on the signal boxes used to go a bluey colour just before it flaked off, as I've tried to suggest here. The exhaust is streaking low over the top of the engine, indicating that it is travelling fast, and the driver is keeping a sharp lookout for a clear road ahead. On a hot day the loco's exhaust would barely be visible, but I feel it was necessary to include it to suggest speed. The light gold of the ripening corn and the parched grass highlights the summer heat. I think this picture will jog happy memories for many people.

Of all the main lines in Britain, the East Coast route allowed for the fastest running over long distances in steam days, since the grades were fairly modest, with gentle curves. Having built up speed on the falling 1:200 gradient from Stevenage, northbound trains would tear through Hitchin, some 3½ miles (5km) distant. Apart from a short stretch through the station, the line continued to descend for the next 5 miles (8km) to Arlesey and, by the time trains passed the signal box at Cadwell, speeds in excess of 80mph (130kph) were commonplace.

No 60014 *Silver Link* was the first A4 Pacific, built in 1935 for service on the 'Silver Jubilee' express between London Kings Cross and Newcastle. The locomotive was fitted with a double chimney in December 1958, when based at 34A Kings Cross, where it remained until withdrawn in December 1962; it was scrapped at Doncaster Works in August 1963, after being stored there for a number of months. Six locomotives of the class have been preserved: Nos 60007 *Sir Nigel Gresley*, 60008 *Dwight D. Eisenhower*, 60009 *Union of South Africa*, 60010 *Dominion of Canada*, 60019 *Bittern* and 60022 *Mallard*.

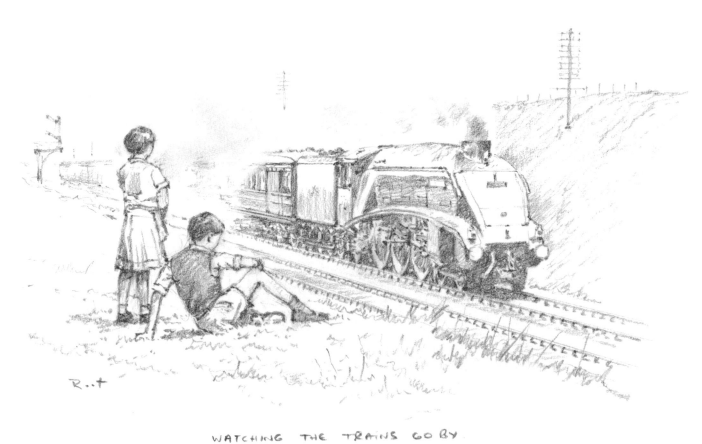

WATCHING THE TRAINS GO BY.

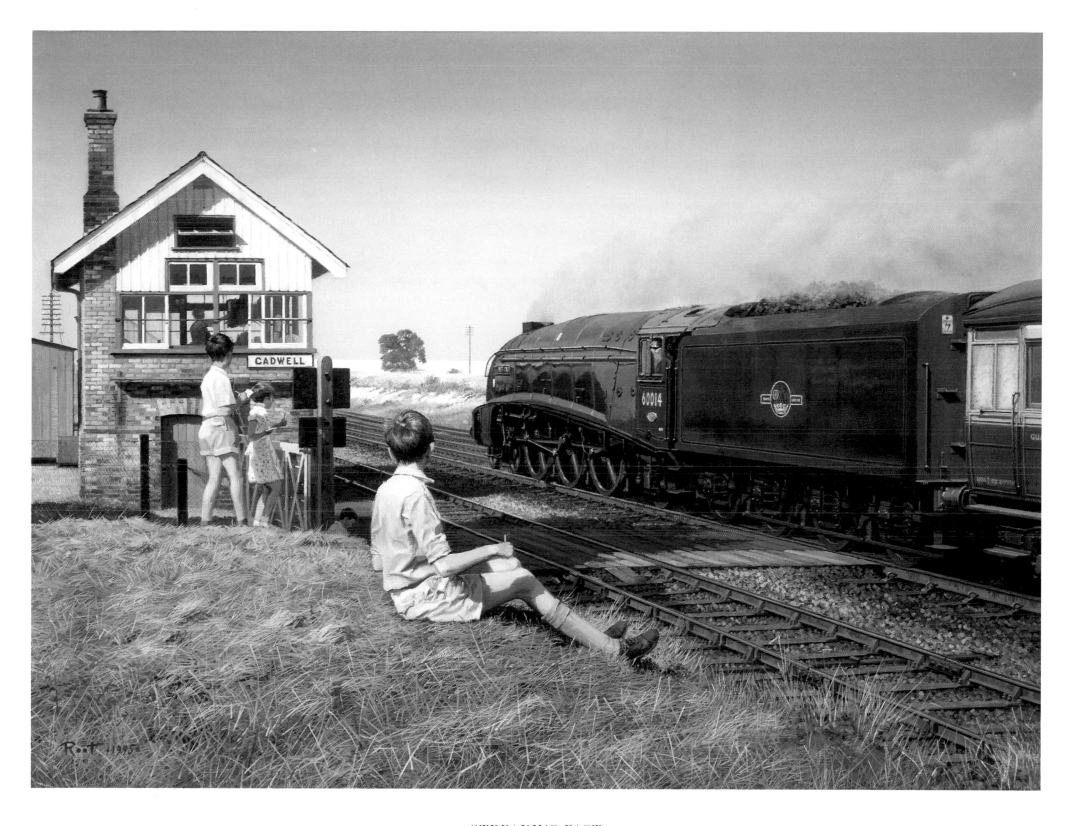

STREAKING PAST

Oil on canvas, 18 × 22in (46 × 56cm), 1995
Owned by Matthew Cousins Esq
(reproduced courtesy Rose of Colchester Ltd)

HOLDING UP THE MAIL

This 1950s scene shows the junction and station at Manningtree in Essex, on the former Great Eastern main line. It features an N7 tank locomotive leaving with a branch train for Harwich and a B17 4-6-0, standing in the station, which would have been going either to Ipswich or to Norwich.

A notable feature of the station was the tall bracket signal on the end of the platform, but the picture is dominated by the level-crossing in the foreground. When you feel that if you were to walk over the level-crossing you would slip on the planks of wood, then you have achieved the desired effect of this being a horrible wet day. It is supposed to be late summer or autumn, but it is a day when one might be better off sitting at home in front of a blazing fire!

The signal wires and point rodding in the immediate foreground, together with the multitude of tracks beyond, make it quite a complicated picture to paint; but this is all part of the challenge which makes one's work so enjoyable. The N7 loco has a burnished metal ring on the front of its smokebox, which was a tradition handed down from Great Eastern days. As a child I remember seeing Morris Post Office vans with little brass fire extinguishers secured to their nearside wings, like the one I have shown here.

Manningtree station was opened by the Eastern Union Railway on 15 June 1846. Although no quayside link was provided to serve the Stour Navigation (since there was one at nearby Mistley), over the years there was sufficient commercial traffic in timber, corn, coal and a large maltings to ensure reasonable revenue for the railway. In 1864 cattle pens were erected to allow livestock to be handled from here.

Introduced in 1914, the N7 0-6-2 tanks were designed for the Great Eastern Railway by Alfred Hill and later developed by Sir Nigel Gresley. These sturdy locomotives were mainly employed on local passenger services throughout East Anglia and were allocated to a number of sheds in the region. The N7s were widely lauded for their spirited performances on the 'Jazz' trains out of London Liverpool Street station serving Ilford, Enfield and Chingford: the GER once boasted the most intensive steam-hauled suburban services in the world. The nickname originated from the jazzy effect of painting different colours over the carriage doors to indicate 1st, 2nd and 3rd class.

No 69614 worked out of 30A Stratford shed for a number of years before being withdrawn in December 1960; none remained in service after September 1962. One example, No 69621, has been preserved by the East Anglian Railway Museum.

HOLDING UP THE MAIL

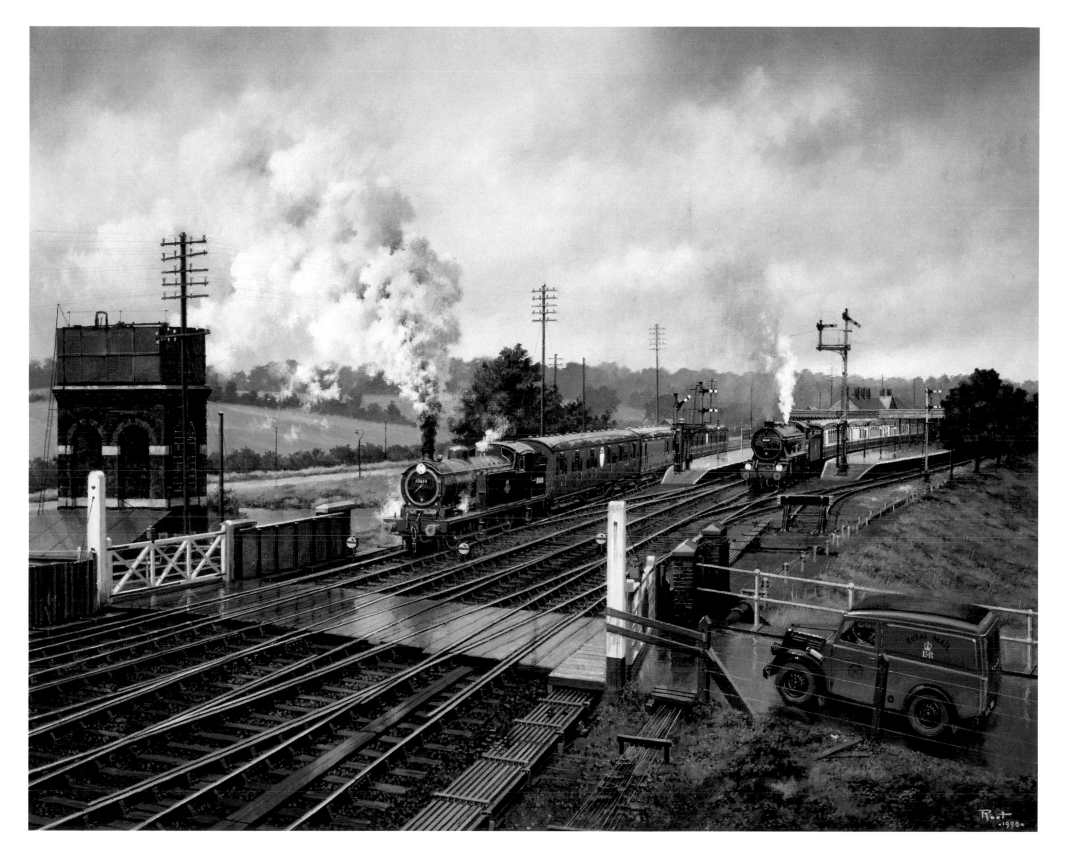

HOLDING UP THE MAIL
Oil on canvas, 24 × 30in (61 × 76cm), 1990
Owned by Robert Clow Esq

71

THE 'DUKE' AND THE CLAN

No 71000 *Duke of Gloucester* and No 72001 *Clan Cameron* stand under the coaling plant at Carlisle Kingmoor. These plants were often a feature of large engine sheds, tending to dominate the skyline and were generally hideous structures made of concrete. In the painting it forms the major part of the left-hand side of the picture and I have tried to balance this by making smoke from the locomotives – particularly from the 'Duke' – a strong feature, so the eye is not automatically drawn to the coaling plant.

The day is shown to be bright and clear with blue sky, which one can see despite the smoke-laden atmosphere surrounding the engine shed. It is a thoroughly grimy scene with piles of ash lying around, planks of wood strewn between the tracks and all the other paraphernalia typically found in these untidy environments.

As well as painting smoke, I'm often asked about portraying spokes and wheels. One can often suggest something is there without showing all the detail by the use of reflections: in this case the 'Duke' has light shining off the rims of the wheels and also between some of the spokes – but you can imagine where the others are. I always think that when you paint smoke, you should feel that you could put your hand right through it and then you know you've got it right.

Class 8P No 71000 *Duke of Gloucester* was the last Pacific to be designed for British Railways and was introduced in 1954 when more modern alternatives to passenger steam locomotives were on the horizon. Although it was built with a double chimney and had a larger fire-grate area than the Britannia Pacifics, the performance was no better and coal consumption heavier. The 'Duke' spent its eight years of service based at 5A Crewe North depot and was not generally popular with the footplate crews.

Withdrawn in November 1962, it spent five years in storage with a view to preservation; however, in October 1967 it was sent for scrapping to Barry Docks. Luckily it survived long enough to be purchased for preservation in April 1974. The general condition of the engine was extremely poor and it was considered an impossible task to return it to working order. After many years of fund-raising and dedicated work by its owners, the 'Duke' was rebuilt to a magnificent standard, much to the credit of all those involved in its restoration.

With the exception of a few months allocated to 64A Edinburgh St Margarets motive power depot, BR Class 6P5F 4-6-2 No 72001 *Clan Cameron* spent most of its years at 66A Glasgow Polmadie, the shed plate of which is shown in the painting.

SHEER POWER.

THE 'DUKE' AND THE CLAN
Oil on canvas, 24 × 30in (61 × 76cm), 1989
Owned by David Dickens Esq

ARRIVAL OF A PRINCESS

This typical scene from the early 1950s shows the arrival at London Euston of an express from the North. These engines always present a slight problem in that being very long, with no smoke deflectors to break up the expanse of tapered boiler, they can look completely out of proportion if you are not careful.

The client and I had a common feeling about Euston station, which always seemed quite dark and miserable and perhaps this impression has stuck from the odd occasion I went there in the 1950s and 1960s. On dismal days, the murky surroundings mixed with smoke always seemed to appear an orange colour and I have tried to suggest

this in the picture – you can almost smell what the place was like, which I remember very well. The gloom is lifted to a certain degree by the lovely blue, which BR used on this class of express locomotive at the time – and the cream colour of the coaches adds a bit of welcome light to the scene. It all helps to create a contrast with the damp and dreary London day suggested here.

What I do like to paint is the difference between the matt of a smokebox on a loco, which contrasts with its boiler: you can show the difference between something which remains reasonably clean and something which shows the effect of heat and grime.

Designed by Sir William Stanier and introduced in 1933, the Princess class 4-6-2s were the first Pacifics on the LMS and in June No 6200 *Princess Royal* was the initial one to emerge from Crewe Works. These magnificent-looking locomotives soon took over the major expresses on the LMS West Coast route, which they later shared with the Coronations.

In November 1936, a test run between Euston and Glasgow was carried out with No 6201 *Princess Elizabeth* hauling a seven-coach train. It covered the 401½ miles (646km) to Scotland in 5hr 53min, cut to 5hr 44min on the return journey: an average speed in excess of 69mph (111kph) for both directions, including topping Shap and Beattock summits at around 56mph (90kph). Quite a performance.

A total of 13 of the class were built, but one, No 6202, was constructed as a turbine-driven locomotive and carried the sobriquet 'Turbomotive'. Despite not being very successful, it lasted in this guise until early 1952, when it was rebuilt in standard form and named *Princess Anne*. It did not last long, however, for on 8 October 1952, it was one of the locomotives involved in the Harrow & Wealdstone disaster and was damaged beyond economic repair.

Built in 1935, No 46210 *Lady Patricia* spent its latter years working out of 8A Liverpool Edge Hill and 66A Glasgow Polmadie, before being transferred to 12B Carlisle Upperby in March 1961, from where it was withdrawn the following October. It was scrapped at Crewe Works in May 1962, 27 years after it was built there. Two of the class have been preserved: Nos 46201 *Princess Elizabeth* and 46203 *Princess Margaret Rose*.

OLD EUSTON

ARRIVAL OF A PRINCESS
Oil on canvas, 16 × 20in (41 × 51cm), 1992
Private collection

DEADLY LOAD

This painting represents the Colne Valley Railway in wartime and the location depicted here forms part of a preservation scheme today. Since the line was well known for its wartime traffic, the picture shows two Class J15s on a bomb train crossing a bridge over the River Colne at Castle Hedingham. During the war hardly any photographs were taken, for obvious reasons, so this represents something which couldn't be recorded then.

There were a number of American airfields in the area and these trains were run to supply bombs for the Eighth Air Force. An aircraft is represented here in the form of a 'Flying Fortress' from the 381st Bomb Group stationed at Ridgewell airfield nearby. The B17 is seen in natural aluminium finish, which was adopted later in the war when the olive green camouflage was dispensed with. This suggests a setting in the summer of 1944.

The branch line ran from Haverhill through to Chappel & Wakes Colne via Halstead, following the course of the River Colne for much of the way, crossing it on several occasions. The train would probably have unloaded its cargo at Yeldham station, a few miles north of this point. Since the track was very lightly laid when built and the bridges weren't that strong, heavy trains such as this had to be double-headed using engines such as the J15s with their light axle loadings. These would have taken over from a larger locomotive at Marks Tey or more probably, Colchester.

The viewpoint chosen for this picture is entirely imaginary, but is slightly elevated to show the river; had it been at track level, this scene would not have been visible at all! Hedingham Castle is shown in the background; it remains today as a fine example of a Norman keep.

A Worsdell design introduced in 1883, the J15 0-6-0s were built at intervals over the next 30 years, until the Great Eastern Railway had 189 of them. With their 13½-ton axle loading, they were a common sight on branch lines all over East Anglia where they were the mainstay of local passenger and light freight services. The last remaining locomotives of this class were withdrawn in September 1962.

Ridgewell airfield, in north Essex, opened in 1942 as a satellite station to Stradishall under No 3 Group RAF Bomber Command. Initially it was the home of 90 Squadron operating Short Stirlings, which stayed from December 1942 until May 1943. On 31 June, the USAAF 381st BG arrived and the airfield was to become the only long-term heavy bomber base of the Eighth Air Force in Essex. In the summer of 1943, several men were killed and aircraft destroyed during the course of a bomb-loading procedure. Of the 296 missions flown by the 381st over the Third Reich, operational losses totalled 131 B17s.

WARTIME WORKHORSES

DEADLY LOAD
Oil on canvas, 20 × 24in (51 × 61cm), 1991
Owned by Jeremy Dunn Esq

TWIN POWER

One of the best things about being an artist is the interesting people I often meet, including the well-known railway photographer Peter Gray. This picture was based on one of his favourite photographs, so my job was made relatively simple. The location is on the Great Western main line in Cornwall between the St Pinnock and Westward viaducts, about a mile west of Doublebois station, and shows an eastbound train headed by a County class locomotive assisting a Grange 4-6-0, climbing hard on the bank. The little signal box on the right is boarded up, obviously having been taken out of service some time before.

What I particularly like about this picture is the way the pure-white steam contrasts with the greyness of the sky, which I exaggerated slightly to produce a more dramatic effect. The real delight for me, however, was the way that the steam penetrated the trees to the side of the track: this was something I often remembered seeing as a child – and to paint it, disappearing amongst the leaves like this, was pure joy and full of nostalgia for me. The reflection of the steam on the track in the foreground gives that damp look after a passing shower on a blustery summer's day and the little bit of colour reflected from the

coaches perhaps emphasises this. It's the kind of day that often makes for a good photograph – and also a nice painting!

Some people say three-quarter views of locomotives can be a bit ordinary, but there are ways and means of making this aspect more interesting and I hope I've succeeded here. Although I haven't painted that many Great Western scenes, I was generally pleased with the outcome of this one.

The photograph to which Malcolm Root refers was taken by Peter Gray on 2 August 1958 and shows ex-GWR 4-6-0 No 1021 *County of Montgomery* heading 4-6-0 No 6808 *Beenham Grange* on the 09.20 (Saturdays only) St Ives–Paddington train, which is shown climbing at 1:90 as it heads eastwards.

The gradients in Cornwall were severe and many heavier trains had to be double-headed, as on the Devon banks between Newton Abbot and Plymouth. For practically all its 75 miles (121km) through the county, the Cornish main line roller-coastered and snaked its way from Brunel's Saltash bridge to Penzance with very few level stretches *en route*. This always presented a problem for any really fast running to be achieved and is still the case today: in 1996 the fastest trains between Plymouth and Penzance, with four intermediate stops, take 1hr 55min westwards and 1hr 42min eastwards: an average of 44.12mph (71kph).

In August 1958, No 1021 *County of Montgomery* was based at 83D Laira Plymouth, whilst No 6808 *Beenham Grange* was an 83G Penzance engine. To the discerning eye, the two-cylinder Hawksworth-designed Counties, introduced in 1945, were never the best looking of the GWR locomotives. Their appearance was not enhanced when they were fitted with double blastpipe chimneys, which made them look rather squat and awkward; No 1021 was thus fitted in October 1959. The Grange class of locomotives, first introduced in 1936, never suffered this indignity and retained their haughty good looks throughout their service.

COUNTY CLASS

TWIN POWER

Oil on canvas, 24 × 30in (61 × 76cm), 1992
Private collection

NOTEBOOKS AT THE READY

This scene of Winchester is based on my happy memories of family holidays spent in the area as a boy and the painting was done simply for my own indulgence. On many occasions we used to go to Winchester before breakfast to watch trains, so that the rest of the day could be spent as a family. A favourite spot to stand was on the end of the station platform and this picture gives the impression of what it was like to witness a Merchant Navy locomotive on a Southampton-bound express tearing down the steep hill from Micheldever and through Winchester. The scene is very much the same today, except all the track shown on the left hand side is now a car park – and you certainly won't expect to see a steam engine!

The painting is full of period detail and some family history: my father's Hillman Minx (complete with correct registration) and my brother's Triumph Mayflower are shown parked near the flat-roofed signal box. The lad standing on the left is supposed to be me, whilst the one sitting on the platform on the right has the 1961 Ian Allan combined volume loco-spotters' book strategically placed next to him. The duffle bag complete with badges: the little wide-necked bottle of orange with silver top; the crêpe-soled sandals and khaki shorts held up by a belt with a 'snake' fastening – all these things remind me of those great times.

I have often been asked why I composed the picture like this, when in some people's opinion, the loco should have been much further forward and more prominent; but it was my intention to show the boys' anticipation and excitement of what the engine was going to be, rather than what it actually was.

On the main line between Worting Junction and Eastleigh, 66 miles 9 chains (106.4km) from Waterloo, Winchester station was opened on 10 June 1839 by the London & Southampton Railway (later part of the London & South Western Railway), although it was not linked to the Basingstoke direction until the following year. From the summit at Litchfield Tunnel, some fifty-six miles from London Waterloo, the main line drops for just over twenty-one miles on a ruling gradient of 1:252 to the outskirts of Southampton. Winchester, about mid-point on this stretch, was an excellent spot to watch down trains as they raced southwards, taking full advantage of the long descent.

The boys would need to be alert to spot (or 'cop') the number because the locomotive could well be doing over 80mph (130kph) at this point. If they managed to read it, the number would be underlined in their Ian Allan 'abc'. These pocket books listing locomotive names and numbers were conceived in the 1930s, when Ian Allan found that no-one else was willing to publish such volumes. By the 1950s, every major station had its group of trainspotters on the platform end or footbridge, each with their 'abc', preferably – if they could afford it – the thick volume combining all BR regions.

Winchester still benefits from an excellent rail service from trains on the Waterloo–Bournemouth and Reading–Portsmouth lines.

WHEN I LEAVE SCHOOL!

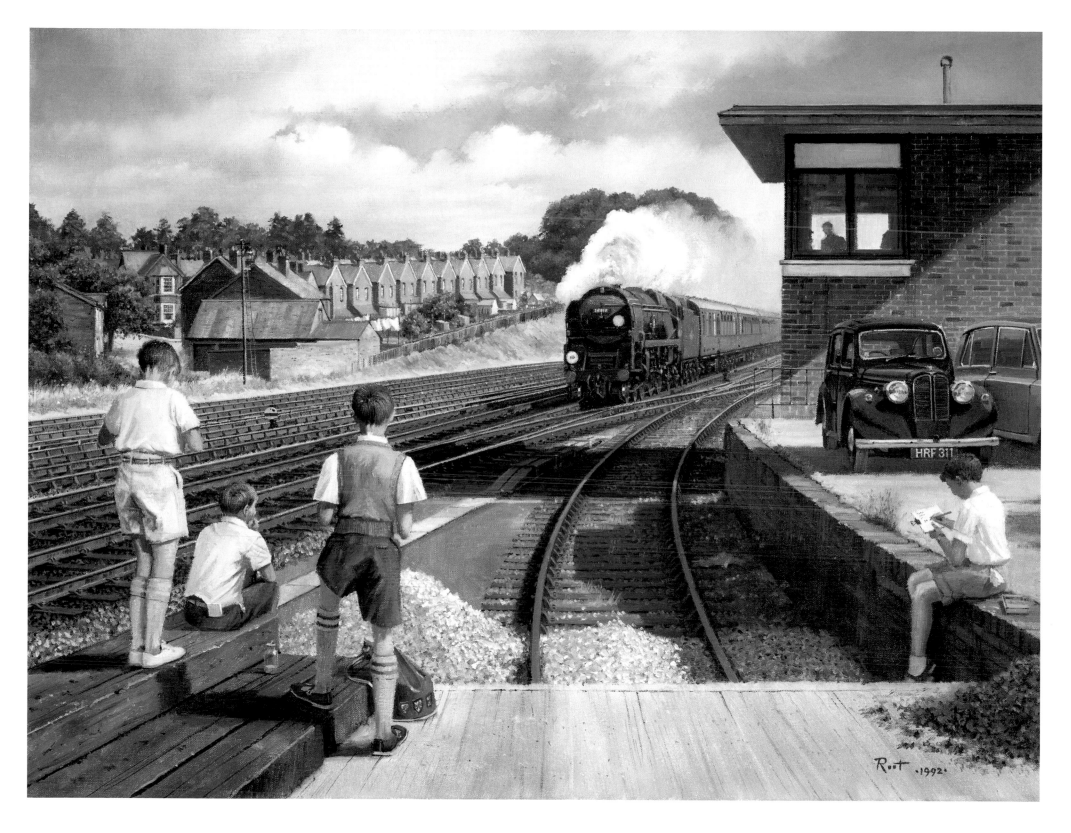

NOTEBOOKS AT THE READY

Oil on canvas, 18 × 24in (46 × 61cm), 1992
Owned by Mrs Barbara Root

THE GATEHOUSE

This painting, showing an elderly J15 locomotive on a level-crossing near Halstead in Essex, on the Colne Valley line, is owned by a lady whose mother was gatekeeper during the 1940s and 1950s. It's a tranquil scene, so reminiscent of a country railway in those days. The cyclist pedalling along perhaps emphasises this atmosphere of calm and contentment.

It was quite a pleasant location to paint and interesting because of the size of the tall signal box – amazing for such a small branch line. The station, a half-mile further down the line on the right-hand side, was on a curve and perhaps this was the reason for the size of the signal box, so the signalmen could see round the bend easily. This viewpoint is actually taken from where my father once had an allotment and where he used to spend a good deal of his leisure time. I remember watching trains from this spot, but hasten to add I wasn't around during LNER days!

As a boy I remember an occasion when I went to this gatehouse for tea. When a train passed, the china on the dresser rattled crazily and I thought it was all going to come tumbling down! I've also a recollection of the signal box on the right-hand side, because although it must have been used in Colne Valley days, it certainly was not latterly and became almost derelict to the extent there was a large crack in the side of the building. Why it was not pulled down I don't know. Like many children in those days, we made little carts from various wheels and planks of wood and I remember going into the building to retrieve an old pram in the basement, which we used as a go-kart. Terrific fun!

Today, just the old gatehouse is left and the signal box has gone – as has the railway of course.

Many of the level-crossings in East Anglia, including the Colne Valley Railway, had attendant keepers who lived in adjacent cottages. These were often manned by the wife of a railway worker, or even by railway pensioners and sometimes invalid staff, who were always on duty as the line's traffic dictated. They were on a meagre wage or railway pension of perhaps a few shillings a week; but this was often supplemented by a rent-free vegetable garden dug on a lineside plot nearby, where they could grow much of the fresh produce they required. Often the odd lump of coal would have been thrown off the tenders of locomotives by drivers or firemen they knew. The footplate crews might have been the beneficiaries of the occasional cabbage or cauliflower from the vegetable plot and exchanged them for fuel for the kitchen stove or parlour fire. A blind eye was usually turned to this minor black-market economy, which helped oil the wheels of the railway when the pay was generally poor.

R.t
Sept 1990

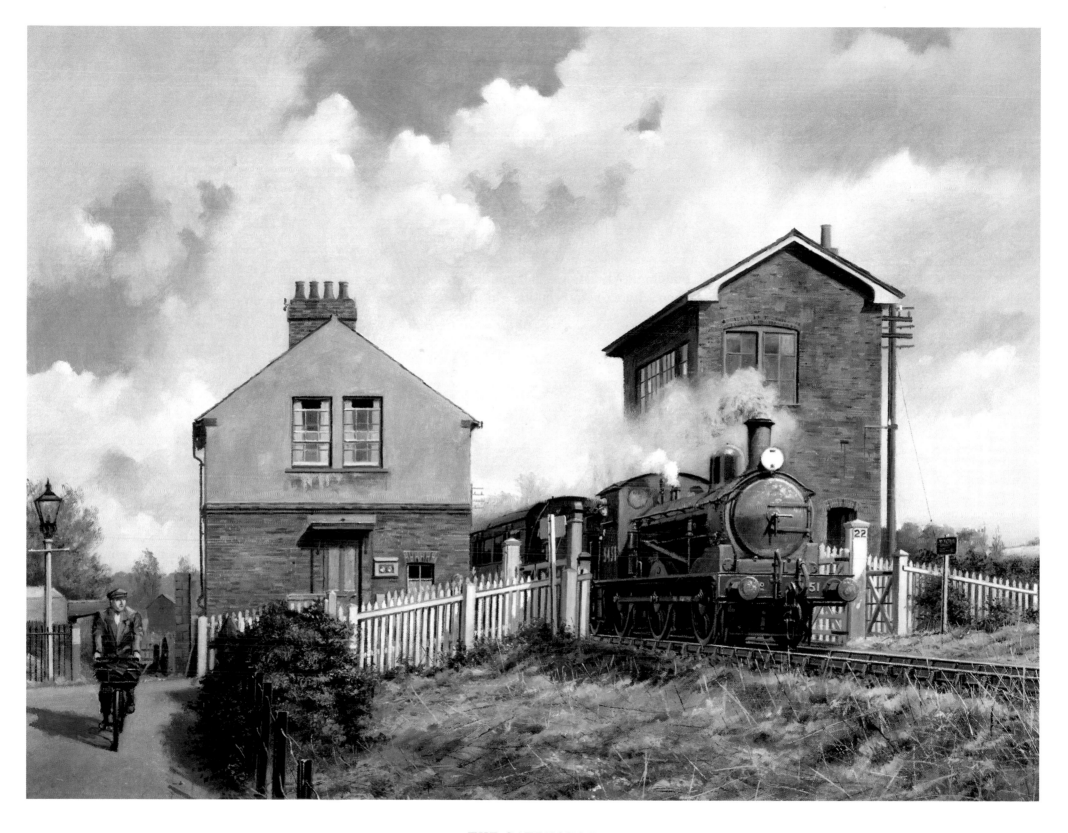

THE GATEHOUSE
Oil on canvas, 20 × 24in (51 × 61cm), 1984
Owned by Mrs Janet Daw

UNDER THE WIRES AT WEELEY

This picture of a B2, No 61644 *Earlham Hall*, at Weeley is owned by the son of a former railway employee, who reckoned he knew of the approach of this engine when it was several hundred yards away by the knocking sound it made: I don't think this was a compliment!

The platelayer shown here on permanent-way work, with a large spanner slung over his shoulder, was his father, Ernest Walter Cole, who joined the railway in 1928 and served for some forty years until his retirement. The gladioli planted in front of the platelayers' hut on the right were his personal trademark and therefore it is appropriate that these have been included. A nice touch. The peculiar-looking shed in the background was just an unloading bay for wagons, as far as I know.

In the artist's eye, this would be a classic example of lines vanishing to a definite point and this effect can be clearly seen beyond the figure's head; it helps to create the overall impression of the speed at which the train would be travelling. The wires were a bit of a problem, because they are notoriously difficult to paint – and I'm not too knowledgeable about the intricacies of electrification! The gantry in the foreground was also challenging and I had to be careful not to make it too overpowering. The natural tendency would be to do just that, but you can overcome this by making it slightly weaker than in real life and it frames the engine quite nicely, I think.

Introduced in 1945, the two-cylinder Class B2 4-6-0 was a Thompson rebuild of an earlier Gresley locomotive, the three-cylinder B17 4-6-0. A total of 10 were rebuilt in this form; they were: Nos 61603, *Framlingham*, 61607 *Blickling*, 61614 *Castle Hedingham*, 61615 *Culford Hall*, 61616 *Fallodon*, 61617 *Ford Castle*, 61632 *Belvoir Castle* (renamed *Royal Sovereign* in October 1958), 61639 *Norwich City*, 61644 *Earlham Hall* and 61671 *Royal Sovereign*. The locomotives were paired with a variety of LNER and NER tenders. The class was extinct by January 1960.

For its last years in service, No 61644 was shedded at 31A Cambridge before withdrawal in November 1959; it was stored at Stratford Works before being broken up there in January 1960.

UP TO THE SMOKE?

R..t

UNDER THE WIRES AT WEELEY
Oil on canvas, 20 × 24in (51 × 61cm), 1990
Owned by Winston Cole Esq

89

MISTLEY

Mistley station on the Harwich branch of the old Great Eastern is the main subject of this painting rather than an actual train, which is incidental. A lot of the traffic that went through here, both freight and passenger, was bound for the continent of Europe. Here a typical goods train is shown passing through Mistley on its way to Parkeston Quay.

This, however, is really an exercise in painting architecture, which I quite enjoy doing; the buildings form nice shapes, interesting angles and often varying lighting conditions. There are also several little details to note, which might not be immediately obvious: the hoist on the back of the maltings seen over the booking hall; the lamp with the station totem underneath and the fire buckets hanging in a neat row on the wall. The once-familiar posters on station buildings and the practice of painting names on factory chimneys are also represented here. Of interest is the tall wooden Great Eastern lower quadrant signal with the repeater arm on the bottom: it is supported by stay-wires which go right across the track to posts on the far side. The other points of note are the different styles of chimney pot on the station roof: all made of different materials! Many of these stations were known for their well-tended gardens, which I have tried to convey in this scene. These things are all reminders of the past which we tend to forget and which, sadly, have largely disappeared.

I deliberately painted the locomotive's smoke drifting down behind the signal box and dissipating in the gap between it and the station. By doing so it was possible to separate the buildings and the maltings chimney to give a feeling of depth to the picture. Perhaps the strong point about this painting is the use of light and shade – the time of day is also suggested by the long shadows cast across the station.

MISTLEY BOX.

R..t

Opened on 15 August 1854 by the Eastern Counties (Eastern Union) Railway, Mistley, the first station on the Harwich branch from Manningtree, was conveniently placed on the south bank of the River Stour estuary. Quayside tracks on a short and steeply-graded branch were laid (strengthened in 1960), which provided a source of revenue from the Stour Navigation in corn, timber and coal traffic. The adjacent maltings, built subsequently, also provided goods traffic for the railway.

With the rapidly increasing rail traffic to and from the North Sea port of Harwich, and nearby Parkeston Quay in particular, double track was laid to Mistley in 1866; the doubling of the whole branch was completed on 6 September 1882. Mistley's population rose from 976 at the middle of the nineteenth century to 1,656 in 1901. Around this time, the making of fertilisers and animal feed flourished, which provided further employment in the area and also another source of revenue for the Great Eastern Railway, who now owned and operated the Harwich branch.

The locomotive depicted in the painting is ex-LNER Class J39 0-6-0 No 64788, which, in the mid-1950s, was a 30F Parkeston engine until transferred to 30A Stratford shed in March 1958. It was withdrawn in June 1959 and scrapped at Stratford Works in July.

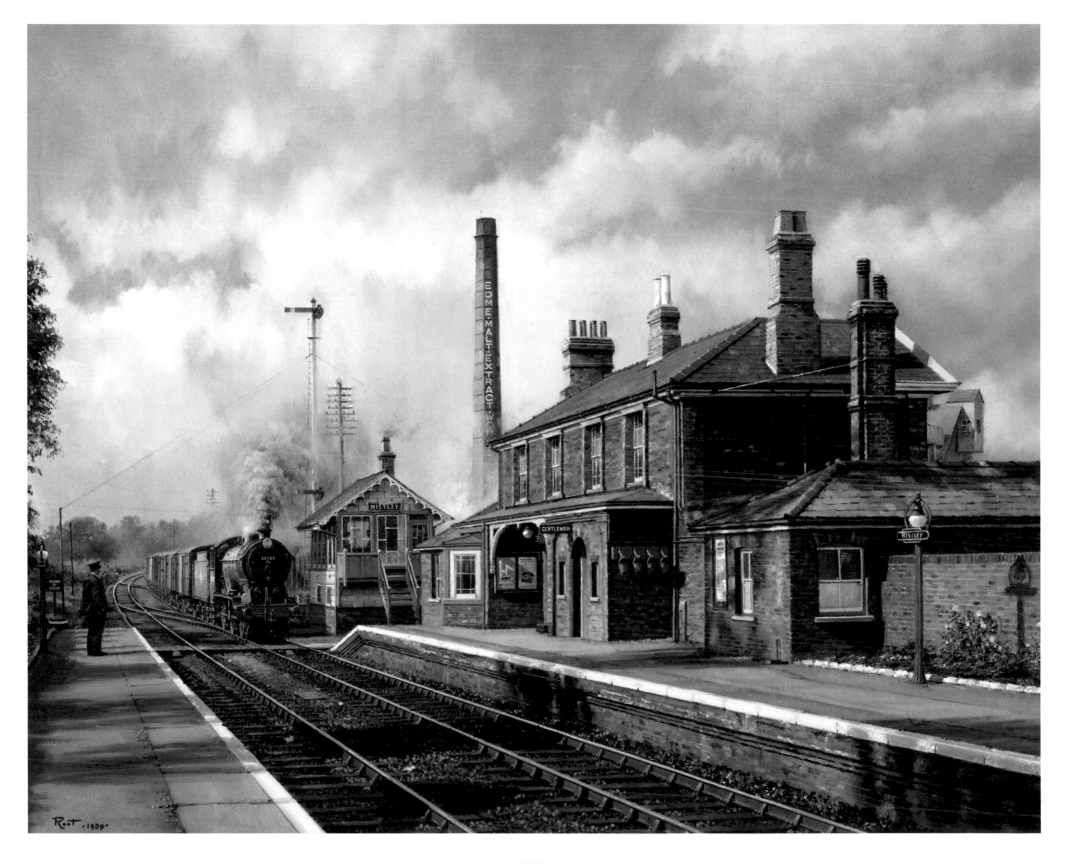

MISTLEY

Oil on canvas, 24 × 30in (61 × 76cm), 1989
Owned by Robert Clow Esq

LIVERPOOL STREET – the Continental Link

Based on a photograph taken by the late Dr Ian Allen (not the 'combined volume' publisher), this painting was originally done to launch a series of prints produced by myself and a colleague. In steam days, London Liverpool Street station was a particular favourite of mine, but it is very much altered now from what it was then. The painting differs slightly from the photograph, insofar as the top of the train shed was obscured by the bridge seen in the foreground, and I have altered the perspective to show the station in full – also there was a diesel standing in it, which I took out and substituted with a steam engine!

I have also included the famous pair of Liverpool Street pilots, by adding the J69 – which was not in the photograph and is the one shown on the right – to the N7. Both engines were beautifully turned out and it was a matter of pride as well as remuneration to keep them clean: the smokebox door rims were burnished and shone up beautifully. One of the figures I painted on the left-hand side was in fact my above-mentioned colleague, who dressed up in railway gear and adopted the necessary stance! Other things which are included in this picture have particular memories for me: the milk bottles on the windowsill on the left-hand side (they seemed to appear everywhere, although how a milkman got here I do not know!); the water cranes which used to drip continually; groups of trainspotters looking over the taxi rank wall on the left, who were there much of the time; and finally, reflection of the water in the inspection pit.

I have also endeavoured to portray the gloom and smoky atmosphere of the train shed's interior, always a particular feature of Liverpool Street. Again, this is a situation where you make the background very weak in order to show up the foreground as a total contrast; it gives the impression of the murk as well as depth. It's amazing how many different colours you can use on the dull brickwork for effect, when they supposedly would all appear to be uniform and sooty in appearance. Not the case.

Britannia class No 70006 *Robert Burns* is shown poised and ready for the road to haul the 'Day Continental': it would shortly have been leaving for Parkeston Quay, where it would connect with the ferry.

Liverpool Street opened as the London terminus of the Great Eastern on 2 February 1874. The main line headed east-north-east through Chelmsford and Colchester to split at Manningtree (for Harwich) and again at Ipswich, for Yarmouth via Lowestoft and Cromer via Norwich; a web of connecting branches served other parts of East Anglia.

The 'Day Continental' was named thus on 14 June 1947 and was the successor to the pre-war 'Flushing Continental' and before that the 'Continental Express'. This and other expresses were run between Liverpool Street and Parkeston Quay, Harwich – a distance of 69 miles (111km) – to serve the ships to and from the Hook of Holland. Over the years timings were gradually improved: today the journey takes around eighty minutes.

For many years Britannia No 70006 *Robert Burns* was based at 32A Norwich, but ended its days working out of 12A Carlisle Kingmoor. It was withdrawn in May 1967 and scrapped at McWilliam's, Shettlestone in November.

OLD LIVERPOOL STREET

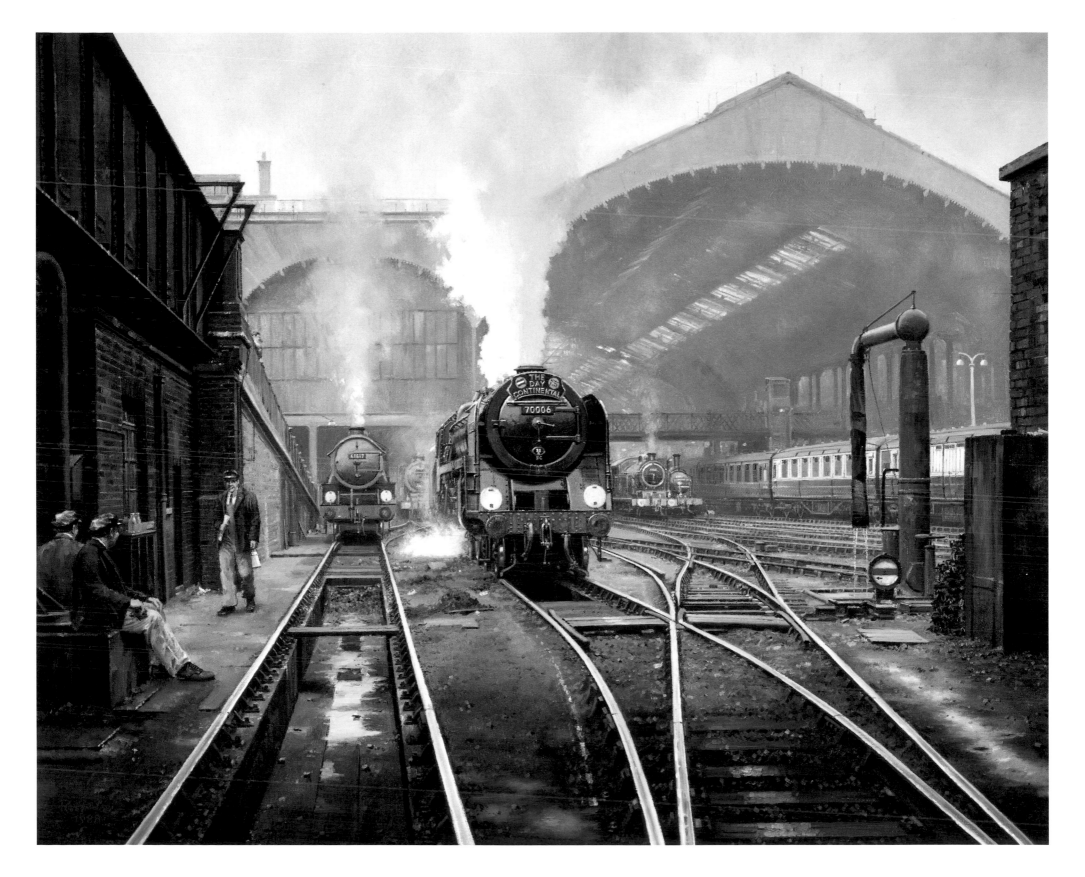

LIVERPOOL STREET – the Continental Link
Oil on canvas, 24 × 30in (61 × 76cm), 1988
Private collection

SEASIDE EXCURSION

Here is a piece of sheer indulgence on my part because I originally painted this picture of Halstead for myself. To me, it sums up one of those days which stay in your memory for ever: the anticipation mixed with excitement of a day by the seaside was highlighted when you walked onto the platform and immediately experienced the wonderful combination of smells that could only be associated with a railway station. On this particular occasion, I remember the bright and cloudless blue sky and it boded well for us if it stayed like that all day. The early morning sunlight was still low, highlighting the front of the Ivatt Class 2 loco as it arrived from the Cambridge direction.

I have tried to incorporate a lot of things in the picture which I recall about the station: the level-crossing by the signal box where, even in those days, there would be some traffic build-up (in this case an Eastern National double-decker Bristol bus is waiting by the gates). Opposite the box there was a large mirror for the signalman to see traffic coming from the right and round a sharp bend, where his view was obscured. Other things are the pub – 'The Locomotive' – in the background; the signalman's bicycle (complete with dynamo hub and chain guard) leaning against the signal box wall; the Woodbine cigarette packet carelessly discarded on the tracks in the foreground – many will recognise this famous brand's design – and odd pieces of rubbish, which blew along the platform and then down onto the railway line.

On the right two children wait for the train and the little girl is carrying one of those metal buckets which I used to find infuriating because,

if they were immersed in salt water, they used to rust and were sharp as a knife and you could cut yourself on them quite easily. It was a similar irritation with the wooden-handled spade, when the metal bit on the end always came loose and fell off! I've also memories of the canvas bag that contained the swimming costumes, towels, sandwiches – and perhaps some cream for protection against the sun, but invariably we still ended up red and burnt at the end of the day!

Straddling the River Colne and set in an attractive valley, Halstead was the largest town served by the Colne Valley Railway. Over the years a variety of industries were attracted to it, including Courtaulds' silk mills, a foundry, flour mills and a tannery, making it one of the largest inland settlements in Essex.

Unfortunately, the town lost its passenger service when the ex-CVR station closed on 1 January 1962, over a year before the infamous Beeching Report was published. The line, however, lingered on for goods or diversionary traffic, until the Halstead–Yeldham section closed on 28 December 1964 and the section to Chappel & Wakes Colne on 19 April 1965.

For much of the 1950s, Ivatt Class 2MT 2-6-0 No 46469 was based at 30E Colchester shed, before moving to 30F Parkeston in November 1959 and then to 31A Cambridge in December 1960. Transferred in June 1962, it ended its days at 31B March before withdrawal in September.

MEMORIES!

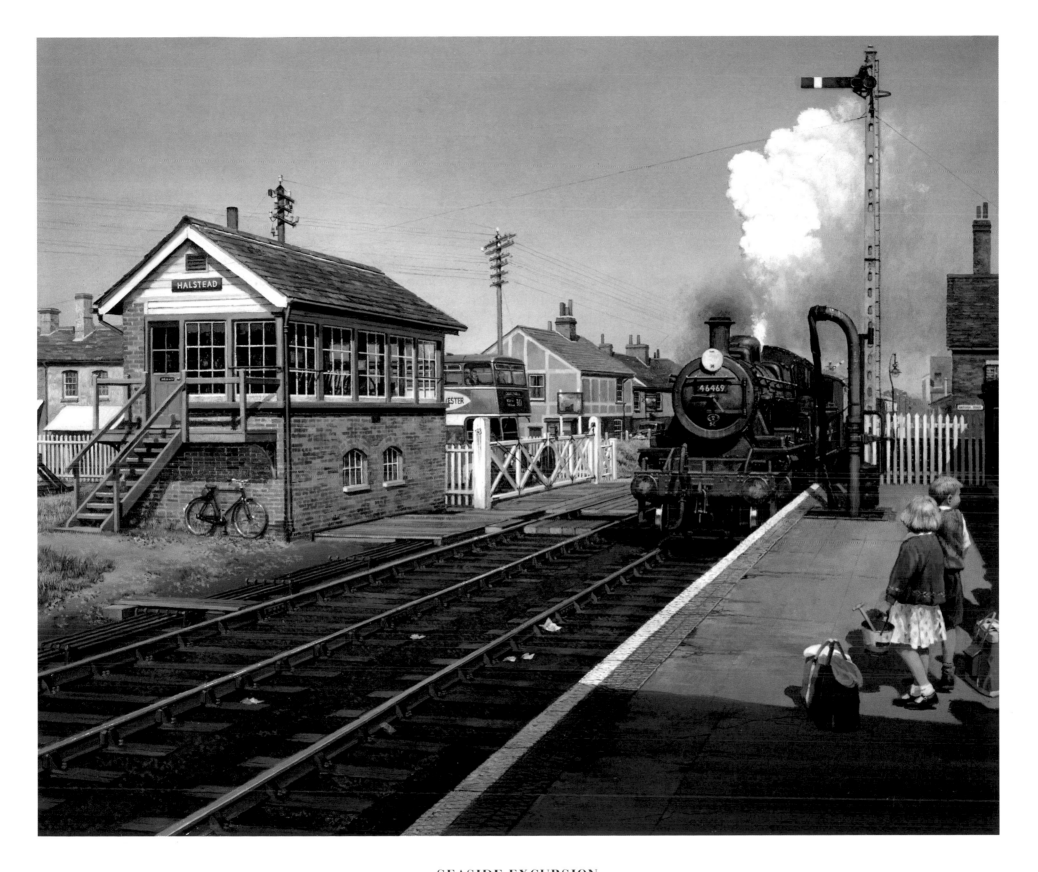

SEASIDE EXCURSION
Oil on canvas, 20 × 24in (51 × 61cm), 1995
Owned by Grimes Fine Art, Moreton-in-Marsh
(reproduced courtesy Rose of Colchester Ltd)

95

INDEX

ACKNOWLEDGEMENTS

Mac Hawkins would like to thank Gerard Hill and Dave Rankin for proofreading the manuscript and their suggestions regarding the text. These have been most helpful, especially concerning historical details, where accuracy is so important. Thanks also go to Mark Curnock of Character Graphics, who has done a splendid job in designing this volume. A particular mention must go to Nigel Cheffers-Heard, who at short notice collected a painting from its owner to enable it to be photographed by him for inclusion in the book. The author would like to pay a tribute to his wife for the unstinting help and advice, which she so readily gave.

Malcolm Root feels a special tribute should be made to Tom Boustead, without whose help the publication of this book would not have been possible, for it was he who suggested that the artist and author should discuss the chances of a joint venture back in 1994. Thanks go to all clients and owners of the paintings, who have kindly allowed them to be reproduced here. Grateful thanks also go to Rose of Colchester Ltd and to Royle Publications Ltd for allowing pictures, to which they hold publishing rights, to be reproduced in this book. The quality and efficiency of Colchester Colour Processors, who produced the majority of transparencies for reproduction, is much appreciated. A debt of gratitude is owed to all the photographers who have allowed their photographs to be used as the basis for some of the paintings featured. The artist would like to offer a special thank-you to his wife and children for their support and help.